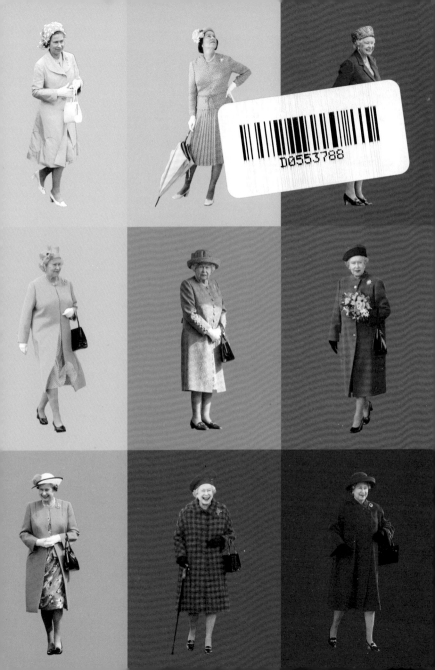

D0553788

OUR RAINBOW QUEEN

OUR
RAINBOW
QUEEN

A TRIBUTE TO QUEEN ELIZABETH II
AND HER COLORFUL WARDROBE

SALI HUGHES

PLUME

PLUME

An imprint of Penguin Random House LLC

penguinrandomhouse.com

Plume is a registered trademark and its colophon is a trademark of
Penguin Random House LLC.

ISBN 9780593086254

Printed in the United States of America

1 3 5 7 9 10 8 6 4 2

Book design by Sophie Harris

For Nicola Ridings Watson

INTRODUCTION

My earliest memory is of sitting in a high chair in the street, semi-stuck to its plastic seat by the rubber pants over my terry-cotton nappy, surrounded by grown-ups and children in paper crowns, while I was fed some unidentifiable goo on a plastic spoon. I didn't realise until later that I, along with the rest of my South Wales Valleys community, and the whole of Britain, had been celebrating Queen Elizabeth II's Silver Jubilee.

The next time I saw the Queen, I knew it. I was six years old and at another street party, this time in Yorkshire, wearing a home-made bonnet made from a disposable buffet plate and red, white and blue crêpe paper, watching the wedding of Prince Charles and Lady Diana Spencer on a television wheeled on an extension lead into a relative's back garden. As the carriages arrived and commentators speculated impatiently on the bride's frock (massive, creased, fairy tale but quite brilliantly of its time), I couldn't take my eyes off the middle-aged monarch in turquoise pleats and a floral hat even my own nan might consider 'a bit old'. As she travelled along the Mall, making a gesture I didn't recognise as a wave, I thought her marvellous, hypnotic, enchanting. And so – rather improbably for the daughter of committed

republicans who'd frankly attended street parties only for the booze – began my lifelong obsession with the Queen. These two vivid memories always strike me as odd because, like my parents, I am neither a royalist nor even, in all honesty, much of a patriot.

It's one thing to spend each weekend sitting with your grandmother reading Ladybird books on the royal family, holding up a viewfinder to the window and clicking through scratchy photographs of the Queen's royal tours, and charting your favourites according to the frock and hat in each, but quite another to be a politically left-leaning adult who can see no compelling argument for the existence of a monarchy (but at the same time, be unmoved by republicanism as a cause, and be in an almost permanent state of fury at our elected representatives) who still absolutely and unapologetically loves our unelected head of state.

It's perhaps more baffling still as to how someone like me, who's made a career from a love and knowledge of fashion, beauty and style, would not count Princesses Margaret or Diana, Duchesses Catherine or Meghan, as her role models, but the royal family member least celebrated for her sense of style: its head. Prim twinsets and matronly kilts, mother-of-the-bride-style duster coats, practical wellies with waxed jacket and headscarf, impeccable military uniform, sensible block

heels and the same black handbag with everything –
high fashion items, these are not.

By contrasting example, the late Princess Margaret,
a royal without portfolio, was often the main attraction,
and delighted in high fashion and statement clothing
in a way her sister, even if naturally so inclined, could
not. Her destiny altered profoundly with the abdication
of her uncle, her young life made earnest, focused,
dutiful and no doubt less fun, Elizabeth could not, as her
sibling did, be seen to take a private plane to Paris purely
in order to try on Christian Dior's New Look. She couldn't
wear skirts above the knee, necklines that plunged,
spend conspicuously large amounts of taxpayers' cash
on up-to-date fashions. Instead, the Queen – while
certainly in possession of a wardrobe of high luxury
and priceless value, at least had to give the appearance
of relative restraint, empathy for her subjects, modesty
and common sense, and she has adhered to the same
principles throughout her reign. Outfits – the dates of
their appearances logged onto a spreadsheet to space
evenly over time – are worn repeatedly. Hats are worn
at least ten times in public before being retired. Shoes
are continually re-heeled until no longer fit for purpose.
Favourite countrywear and riding gear is worn for
decades, their free replacement refused. Even the
Queen's own wedding dress was bought using ration
coupons, and when her chosen design exceeded

her fabric quota, brides-to-be all over the country sent her their spares (she returned them all on the basis that transferring ration coupons was not strictly legal).

But the Queen is driven by duty, and this in turn guides her wardrobe choices as it does every other decision. She wears bright colours because she believes it's her duty to be seen by the people who've waited, wet and cold, behind barriers for hours at a time. She prefers three-quarter-length sleeves because she believes it is her duty to wave at well-wishers for several hours unimpeded. At international events, she chooses colours that imply no allegiance to a single flag, because she believes it is her duty to be neutral and respectful to all nations. She wears a single corrective shoulder pad because she believes the monarch should stand straight before her subjects. Everything must be hemmed with curtain weights to avoid the vulgarity and humiliation of what we now refer to as 'up-skirting'. Clothing is not simply for Elizabeth II herself, but for the monarchy, and it must uphold its highest standards. The Queen's job is to be smaller than the throne and she has always understood this perfectly.

The Queen's most faithful suppliers are rewarded. Royal warrants are key for designers, retailers and other fashion and beauty houses, who can apply for an entitlement to display the royal arms on their

shopfronts, websites and marketing materials only when they have supplied the royal household (specifically the Queen, Duke of Edinburgh or Prince of Wales) with goods or services for at least five years out of the last seven, including during the last 12 months. The warrants, renewed or expired every five years, are currently held by some 800 businesses across trade and industry, many of them in fashion, from Cornelia James, which provides the white cotton day gloves and nylon evening gloves the Queen changes several times a day when on duty, to the brilliantly named Corgi Socks, who, alas, do not supply hosiery for Vulcan and Candy, Her Majesty's two remaining dogs. In beauty, Yardley, Floris, Clarins, Elizabeth Arden and Molton Brown all get the royal seal of approval for their perfumes, skincare, cosmetics and toiletries, while Launer (the makers of some 200 of the Queen's handbags) has proudly held its warrant for over five decades.

However long their association with the Queen, holders of a royal warrant must adhere to a code of conduct in return for the prestigious association, and they dishonour it at their peril. Holders must never claim or imply any exclusivity and while their association with the palace may be overt, the details of their working relationship should remain suitably discreet. In 2018, June Kenton, director of Rigby & Peller,

the long-time suppliers of corsetery and lingerie to the Queen, Queen Mother and Princess Margaret and holders of a royal warrant since 1960, wrote a book entitled *Storm in a D-Cup*, in which its author revealed details of her unarguably sensitive work with the palace. The company, perhaps inevitably though without explicit explanation, saw their warrant cancelled soon after. One can't help but wonder what on earth else they expected.

What one might not instinctively imagine, but what holders of the warrant know to be true, is that the Queen's style remains relevant from a cultural standpoint and consequently still very much shifts stock. In 2016, during her 90th birthday celebrations, the Queen's neon-green suit worn to Trooping the Colour launched a trending Twitter hashtag #NeonAt90, and it is claimed that in the days that followed, sales of neon-coloured clothing and accessories rose sharply by 137%. Five years earlier, Her Majesty had carried a beige Launer handbag into Westminster Abbey for the wedding of Prince William and Catherine Middleton and, almost instantly, Selfridges sold out of all Launer bags. Here but especially overseas, the Queen's wardrobe choices convey to a brand a sense of quality, endurance and quiet luxury. In fact, her lack of interest in fashion for its own sake works in her favour.

And yet the Queen most certainly knows what works. Her love of 'colourblocking' – the wearing of a single-colour outfit, seen throughout this book – is born from practicality. She understands her job is to be seen and, standing at just 5'3" (I know the feeling), needs all the help she can get. A dresser's attempt to modernise her wardrobe for her Canadian Tour of 1970, on which she wore slacks, was unsuccessful. Trousers have made not a single official appearance since (again, I relate). She prefers dresses to skirts, because they're more comfortable and she has no time to tuck in and straighten up whenever she exits a car, won't wear green to grassy venues, nor dark colours against dark upholstery, and will not entertain a heel higher than 2.25 inches (okay, this is where we must part company).

Behind every famous clothes horse, there is, invariably, a tastemaker or stylist at the reins. The Queen is no exception, though her official dresser, Angela Kelly, downplays her role. Her CV is modest, but her influence and expertise, huge. The Queen discovered Liverpudlian Kelly – over 40 years her junior – while she worked as housekeeper to the British Ambassador to Germany and soon offered her a job. Kelly rose fairly swiftly through the ranks to become the Queen's personal dresser and now, along with her team, selects, maintains and archives her clothing, shoes and accessories, even designing and making much of

it herself (milliner Rachel Trevor-Morgan and designer Stewart Parvin are among the Queen's favourites outside of the palace). It was at Kelly's suggestion that her employer joined forces with the British Fashion Council in 2018 to found the Queen Elizabeth II Award for British Design, resulting in the Queen's first ever appearance at London Fashion Week and an already iconic photograph of Elizabeth II sitting front row at Richard Quinn with US Vogue editor Anna Wintour, who, marvellous though she is, did not remove her sunglasses while conversing with the Queen. Call me old-fashioned, but who keeps on their shades while speaking to any woman in her nineties, royal or not?

Significantly, the award was founded 'to recognise emerging British Fashion Talent, to provide a legacy of support for the industry in recognition of the role fashion has played throughout the Queen's reign and continues to play in diplomacy, culture and communication', and I think this crystallises why the Queen's style is so hugely impressive to me. What she cannot overtly say with language, she secretly says with clothes. Truly, Elizabeth II's quiet, devastating trolling through fashion could inspire an assassin. The coded handbag positioning, signalling to staff that some dignitary is now rather quacking on. The European blue and yellow worn to open a post-Brexit-referendum Parliament. The polite silk head covering while she

bombed around in a Land Rover, a mortified then Crown Prince Abdullah of Saudi Arabia having to sit next to a female driver for the first time in his life. The wearing of a Barack and Michelle Obama–gifted brooch for a meeting with Donald Trump, for which the 45th US president arrived, staggeringly, twelve minutes late and blocked his 92-year-old hostess's pathway so she had to scuttle around him.

We will, of course, never know what is calculated and what is delicious coincidence. Because like fellow British style icon Kate Moss, our inscrutable Queen never complains, never explains. And that, to me, is her great appeal. In an age of oversharing, when vloggers propose marriage to one another on YouTube and Z-listers share their breakfast, lunch and dinner with millions, I am comforted by the Queen's constant dignity and mystique. I love that we can only speculate as to what's in her handbag, don't know what she wears to bed, what is engraved on the inside of her wedding band, or even what she thinks about most things. I admire the stoicism, restraint, the self-control and stiff upper lip. It means that when a tiny private detail does slip through the net (like her insistence to a former First Lady that lipstick can be applied publicly at lunch – right on, QEII), it still gives me a thrill, just as it did in childhood.

I dread losing the Queen because, to me, she represents a sturdy, dutiful, unselfish type of woman that is fading from British culture. Those women who look as though they could build a roaring fire, pluck a grouse and lamb a sheep without breaking a sweat inside their Barbour. She is the only public figure I cannot remember not being there. She has always been present – solid, dependable, appropriate. It's entirely correct that she is now officially Britain's longest-reigning monarch. And how utterly fabulous that she did it in leopard, flowers, tartan and neon.

Sali Hughes,
December 2018

OUR RAINBOW QUEEN

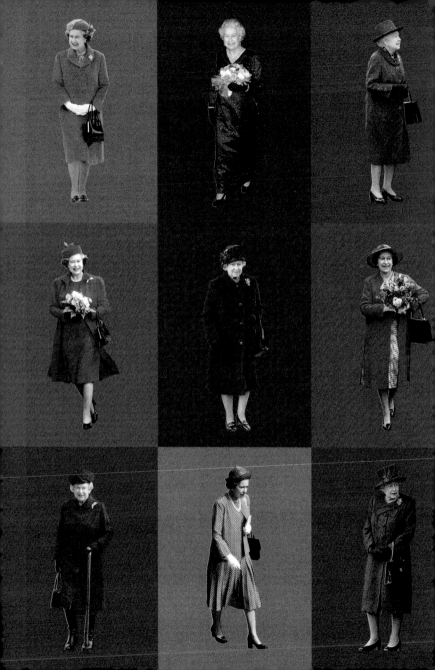

RED

Queen Elizabeth II has seen red almost every day of her reign. The bright scarlet correspondence boxes delivered to her each morning, the tunics of the guards outside Buckingham Palace, the walls of the throne room and state dining room at Buckingham Palace. Bold scarlet and rich maroon have featured in her public engagements, too. She is keen on rich red tweeds and wool bouclé in crimson, cherry and burgundy. Sadly the occasional slash of red lipstick has been retired.

Queen Elizabeth II accompanied by Walter Scheel, then president of the Federal Republic of Germany, wears national colours of black and red to inspect a guard of honour in Germany, 1978.

Even when taking tea at home with commoners – in this case Mrs Susan McCarron, her ten-year-old son, James, and Housing Manager Liz McGinniss in the Castlemilk area of Glasgow in 1999 – QEII does not remove her coat. She is never seen to do so in public.

Inspecting a guard of honour during her Silver Jubilee visit to Scotland in May 1977. Note that the usual white gloves have been replaced with black, so as not to mimic the military uniform, or to indicate the incorrect rank.

2015 Christmas Day church service at Sandringham. The Queen holds her signature Fulton transparent 'Birdcage' brolly (she has dozens, each with a different custom-coloured border to complement all outfits), so as not to obscure her face to crowds.

The Queen arrives at the races in Riyadh in spring 1979. It is usual for her dresser to travel ahead to ensure clothing adheres to local customs and complements and flatters individual locations and backdrops. Here, a scarlet frock and jacket with black accessories match the traditional red-and-white ghutra headwear of her hosts.

Hats must be tall enough to be seen, short enough to remain secure in a car, and narrow of brim to allow subjects to see the monarch's face. A public 'walkabout' after attending Sunday service at the Church of St Peter & St Paul, West Newton, in February 2016.

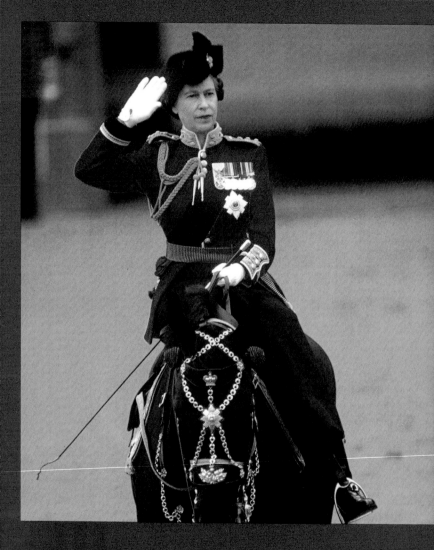

Riding pillion at Trooping
the Colour, 1979, in the same
traditional red tunic worn
by the Queen's foot guards.
The bearskin busby is made
more feminine and decorative,
and is unique to her.

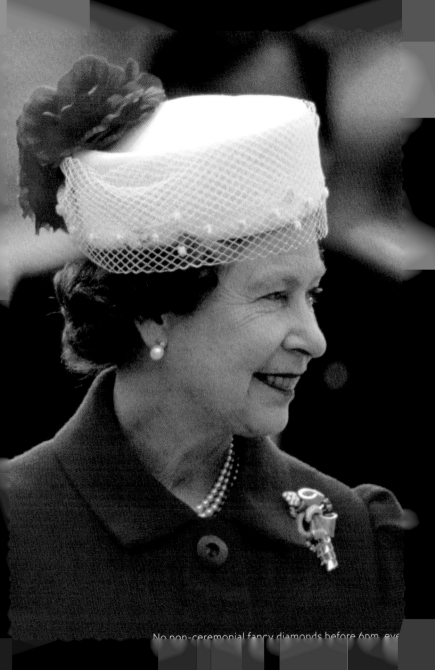

No non-ceremonial fancy diamonds before 6pm, eve

At Cambridge University, March 1996. The Queen owns hundreds of square silk scarves – many of them custom-made – by French luxury house Hermès.

In a red pencil suit with black accessorie[s] [and,]
unusually, a bold red lip, the Queen visi[ts]
Roberts's workshops in London's Kens[ington,]
Novembe[r ...]

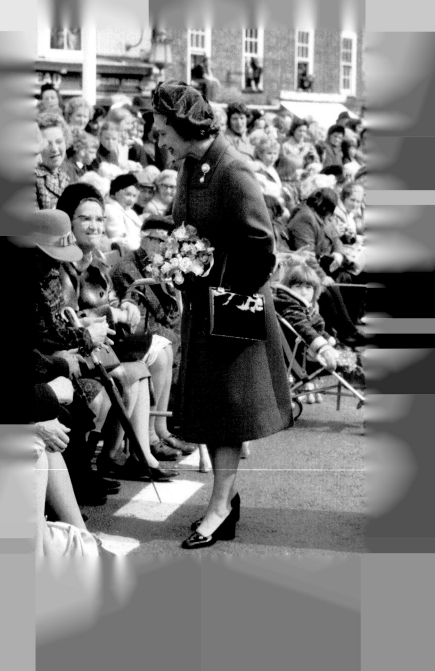

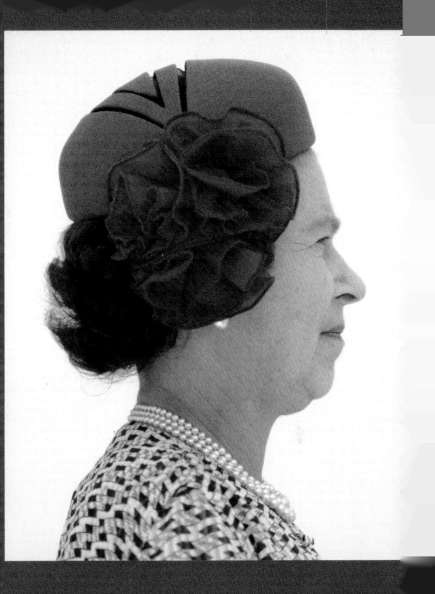

November 1983. Visiting the Indian
National Defence Academy in Pune,
wearing red, a colour signifying power,
strength and prosperity in Indian culture

St Petersburg in
October 1994. The
Queen frequently
chooses clothes to
match a host nation's
flag. Russian Red
became a less
contentious choice
post-glasnost.

Attending a service for the Order of the British Empire at St Paul's Cathedral in March 2012. The Queen typically wears this satin robe, gold collar and blue cross badge only once every four years.

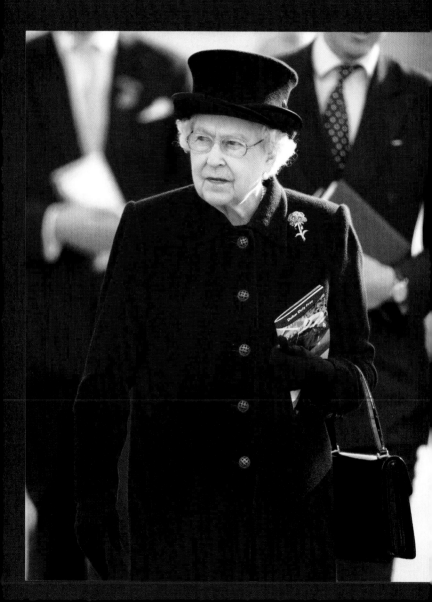

Attending the Dubai Duty Free Spring Trials meeting at Newbury Racecourse in April 2014.

The gloves are off. Later that same day, at home in Windsor, minus hat, specs, gloves and bag. The Queen and Duke of Edinburgh had been dining with then Irish President Michael D. Higgins and his wife, Sabina, and so accordingly, gloves would have been removed, finger by finger, and placed discreetly on the lap, under her napkin.

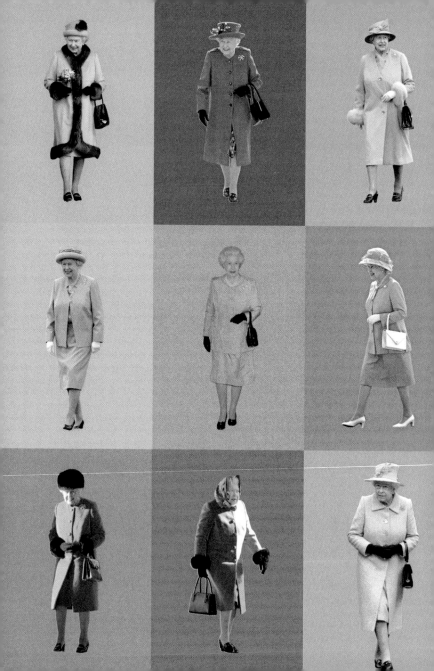

ORANGE

Tangerine can be tricky to wear, but
it hasn't deterred the Queen. Orange is,
in fact, a handy colour for international
events, since it appears in few flags
(India is a notable exception) and is
consequently a safe bet when conveying
neutrality is tactful. Burnt or bright
orange suits her well, but she looks
especially good in softer peaches and
corals, which flatter all skins and ages
and conveniently look fabulous
with diamonds.

Opening the New Welsh National Assembly building in Cardiff Bay, 2006. The Queen has been criticised in the past for wearing real fur, especially a full-length mink, her favourite since 1961. Notably, a faux-fur alternative to the iconic bearskin headgear worn by the Queen's Guards is in development, at PETA and designer Stella McCartney's suggestion.

Queen Elizabeth II at the Quirinale Palace, Rome, October 1980. Women who enter the royal family as commoners never wear tiaras before marriage (royal brides, like the Duchesses of Cambridge, Wessex and Sussex, typically borrow one from the Queen to wear on their big day, as did the Queen's daughter, Anne, the Princess Royal).

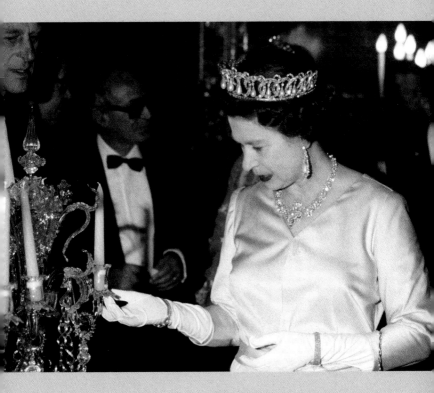

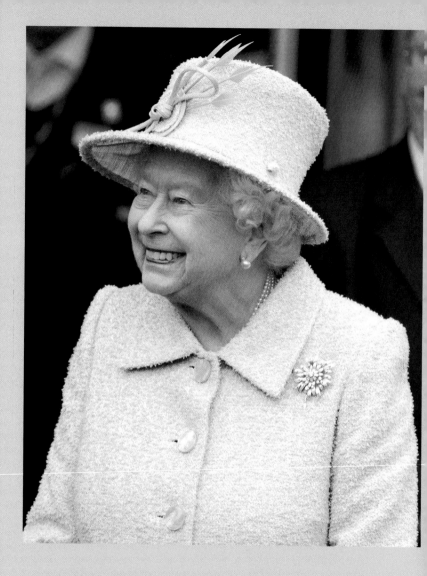

Attending Sunday service near Sandringham, January 2014. Angela Kelly, the Queen's dresser since 1993, says her boss is an expert in fabrics. 'It has not been a question of me teaching the Queen – it has been the other way around.'

White gloves and white picket fences. The Vivari Queen's Cup Final, June 2007, at Guards Polo Club. This, like all of the Queen's public outfits, would first have been weather-tested by Angela Kelly – with the help of a powerful fan to mimic high winds. All the Queen's hemlines are weighted down to make for a smooth silhouette and no blustering skirts.

Queen Elizabeth honours the Indian flag with an orange-and-white outfit for a 1997 visit to Raj Ghat, the site of Mahatma Gandhi's cremation.

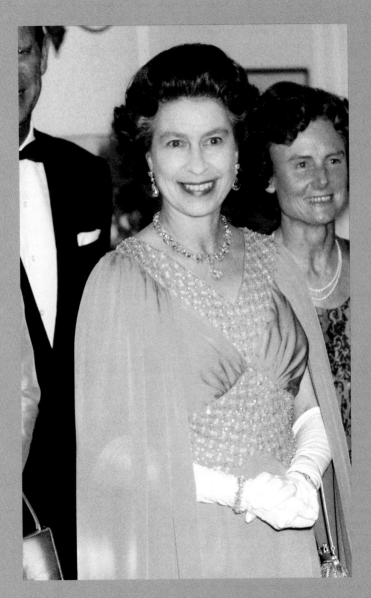

Wearing a peach gown, circa 1980.

In Stabilo highlighter pen orange, at a reception to mark the 80th anniversary of the Royal Auxiliary Air Force, London.

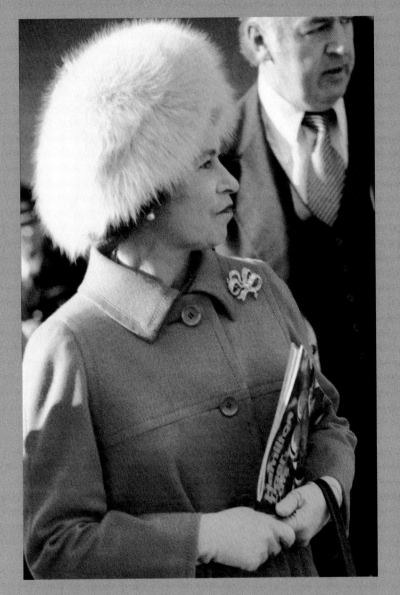

In 1983, during her tour of Canada, where the wearing
of fur is less controversial, and where bearskins for
the Royal Guards' helmets are sourced.

The Queen's favoured companion, a black patent leather Traviata handbag, attends a Christmas Day service at St Mary Magdalene Church on the Sandringham estate. The bag's maker, Launer, has held a royal warrant since 1968, since which QEII has amassed a collection of around 200 bags, each costing approximately £1,500.

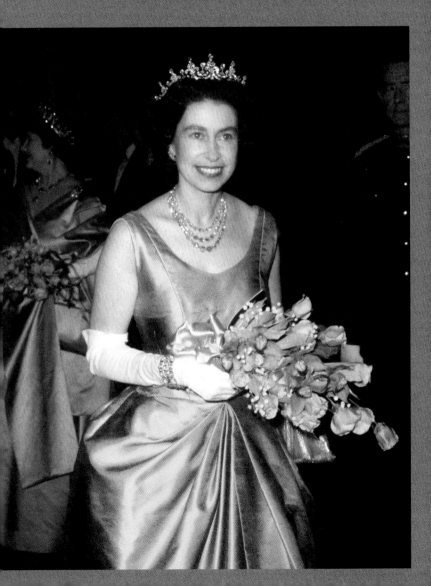

A very rare sighting of the Queen's arms at a performance at RADA, London, November 1964. Dress gloves take the curse off and restore modesty.

The Queen, accompanied by the Duke of Edinburgh, travelling in an open-topped car towards Buckingham Palace for the 2002 Golden Jubilee celebrations. The three-strand, diamond-clasp pearl necklace (an Elizabeth II signature) is likely one given to her by the Emir of Qatar for her coronation in 1953 (postponed to allow Britain and the royal family a mourning period following the death of George VI). Her wedding band features a personal inscription that has remained a secret between the consort and his wife.

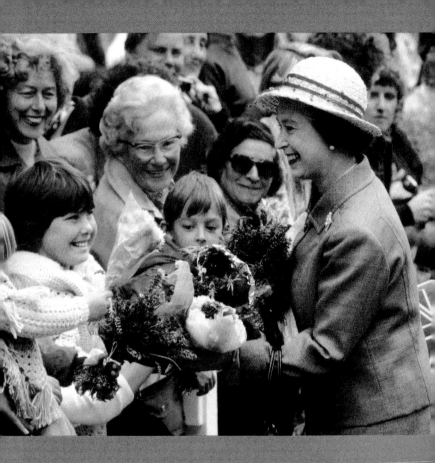

On a walkabout in
Australia, October 1981.
The Queen's Launer
handbags are custom-
made to ensure optimum
handle drop for smooth
handshaking, comfortable
carrying and unencumbered
posy-collecting.

Wearing a silk headscarf and orange coat to the polo at the Guards Polo Club in Windsor, June 1985.

Attending the Christmas Day
2017 church service at the
Church of St Mary Magdalene,
in a burnt-orange coat.
The gloves will be just one
of the pairs carried by the
Queen's ladies-in-waiting.
As well as spare gloves,
they are said to travel with
spare tights, sewing kits and
lavender-scented cloths in
case of extreme heat.

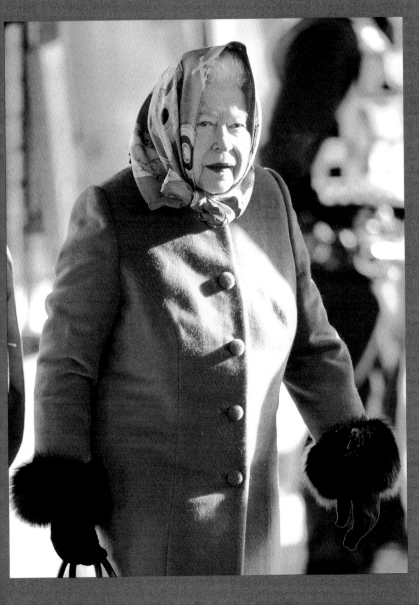

Banishing back-to-work blues in a bright Hermès headscarf and satsuma coat. The Queen boards a return train to London after her 2017/18 Christmas break at Sandringham.

YELLOW

Primrose, marigold, lemon and
daffodil – the Queen understands
what woefully few of us realise –
yellow flatters everyone. She wears
yellow frequently, particularly in
spring, when she embellishes it with
flowers and accents of blue. She has
worn yellow gold, one of Australia's
national colours, on every royal tour
of that country and she wore it to the
wedding of her grandson William.

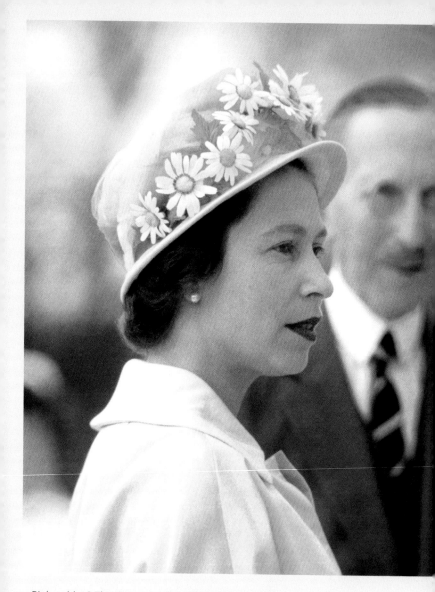

Pink or blue? The Queen hedges her bets for a visit to Glasgow's
Royal Maternity Hospital in the summer of 1962. Daisies, traditionally
given to new mothers, are symbolic of childbirth and motherhood.
Truly, there are few coincidences in the Queen's working apparel.

Washed-out primrose, punctuated by neon-pink accessories and lipstick for Derby Day. The Queen watches the racing from the balcony of the Royal Box at Epsom Racecourse in June 2015. Since 1998, her hair has been styled by Ian Carmichael, sometimes based at the in-house salon at London's Dorchester hotel, who was made a member of the Royal Victorian Order by his favourite client.

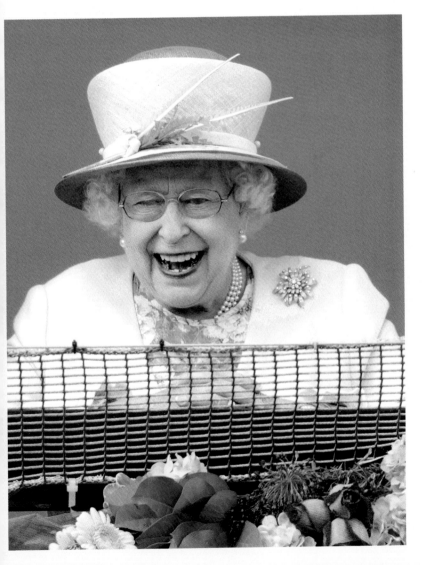

Attending a state banquet hosted by President Ivan Gašparovič at the Philharmonic Hall in Slovakia, October 2008. The Queen wears a tiara only for state events, and reserves predominantly diamond jewellery strictly for evening engagements (hence the upper-middle-class phrase 'diamonds in the daytime' as a withering and dismissive description of a more vulgar member or interloper).

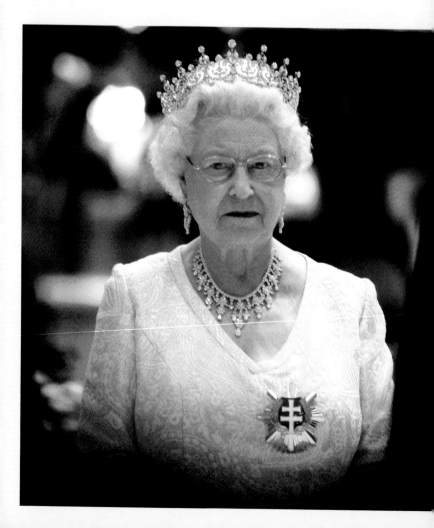

Canada, July 1976.
Queen Elizabeth II
always wears gloves
for walkabouts,
to protect her hands
from germs. Her former
daughter-in-law, Diana,
Princess of Wales,
rejected the custom
to minimise perceived
distance between
her and the public.

Attending the Commonwealth Day Service at Westminster Abbey in London, March 2017. The yellow (her preferred colour for Commonwealth events) and sunburst feather plumage are likely a nod to the Commonwealth of Nations flag.

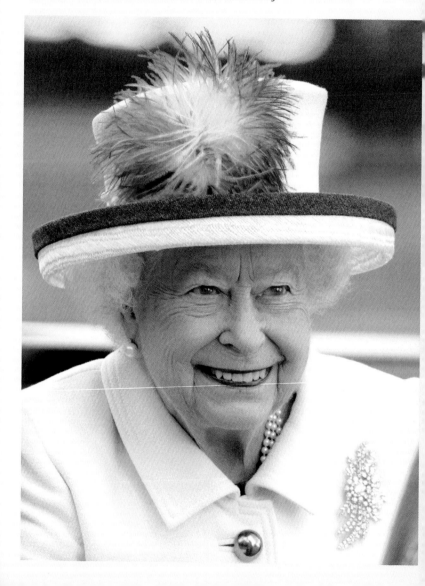

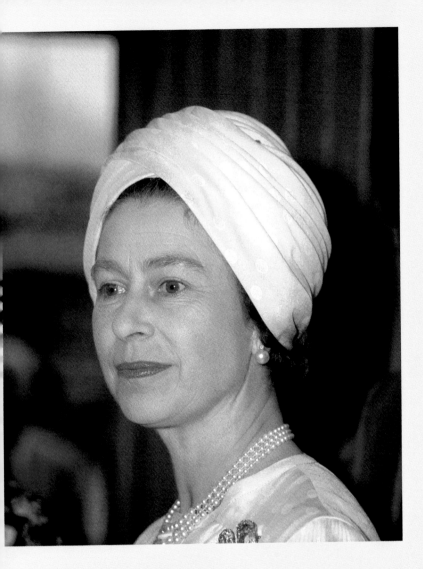

In Mexico during the 1975 state visit, wearing a polka-dotted frock and turban in buttercup. Until the early 1990s, the Queen routinely had her hair coloured in a shade named Chocolate Kiss.

A walkabout in Bexleyheath in 2005. Fuschia lipstick – probably by royal-warrant-holding Clarins or Elizabeth Arden – brightens pastel ochre polka dots.

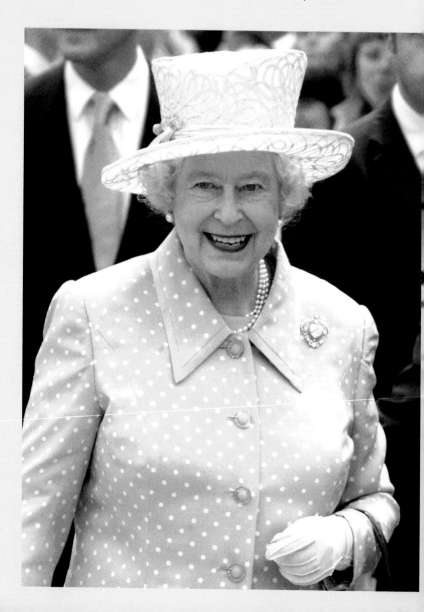

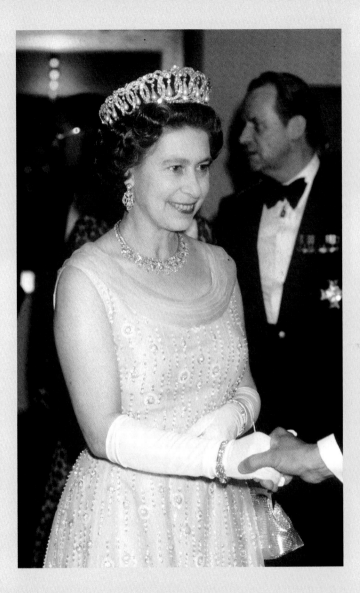

A silk-sheathed handshake at a German banquet in May 1978. Mayfair glove purveyor Cornelia James has held a royal warrant ever since.

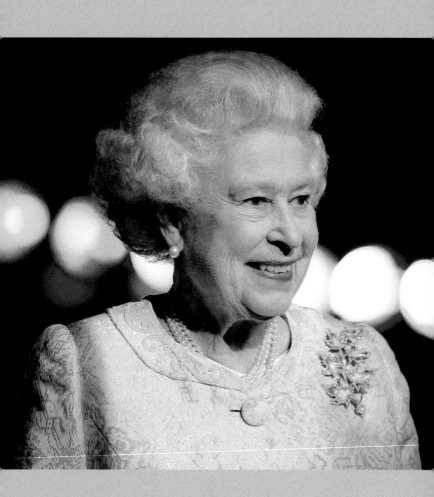

The Queen is apt to let her brooches do the talking.
Here, she attends a summer 2010 reception to
celebrate the centenary of the Canadian Navy and
to mark Canada Day, wearing an elaborate pin
featuring the maple leaf – the Canadian national
emblem. As well as some three-strand pearls, naturally.

With Prince Philip, at a 1979 dinner in Dubai. Sunny yellow chiffon is weighed down by serious diamond jewellery, including the Star of the Order of the Garter.

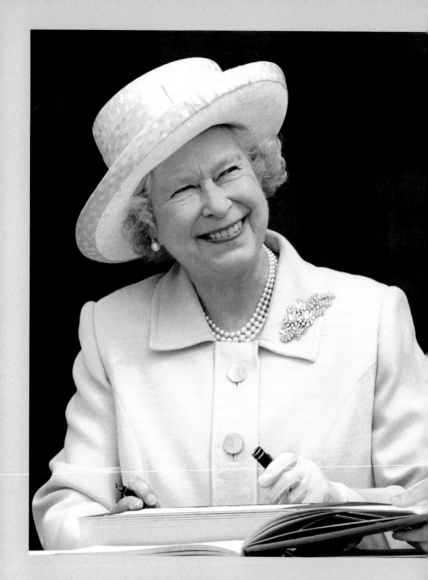

Despite conducting most royal duties in Cornelia James gloves, the Queen still removes the right-handed one for any writing, including the obligatory entry in visitors' books. Nails are always either bare or painted in Essie's Ballet Slippers, a soft, palest pink. Meghan, Duchess of Sussex, was criticised in 2018 for breaking royal protocol with a dark, lacquered manicure.

In Muscat, Oman, with Sultan Qaboos in February 1979. The Queen is said to always carry a small camera in her handbag, for the impromptu taking of private snaps.

In a turban-style yellow-and-turquoise hat, pearls and simple jacket on the royal yacht at Portsmouth Dockyard, August 1996...

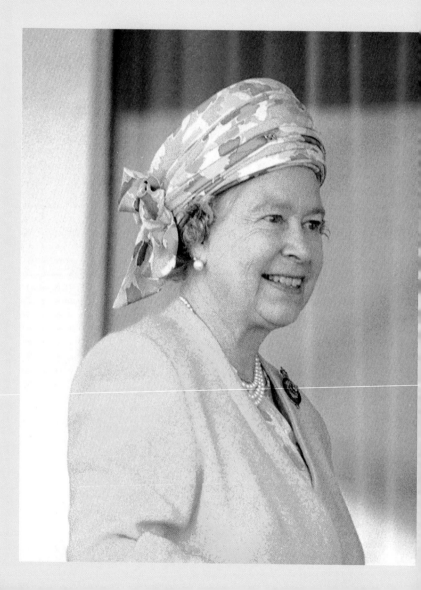

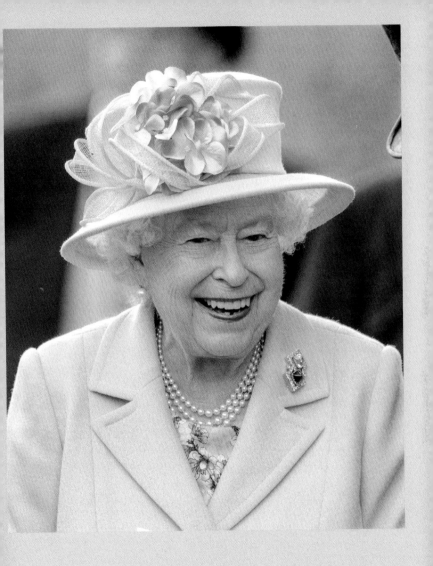

...If it ain't broke, don't fix it. At Royal Ascot twelve years later, in an almost identical scheme and the same beloved pearl necklace and earrings.

In Southampton, circa 1986, in a yellow and navy outfit by Ian Thomas who, as a junior designer, had assisted Norman Hartnell in making the coronation robes. Thomas also designed and made the ensemble worn by one of the Queen's likenesses at Madame Tussauds in London.

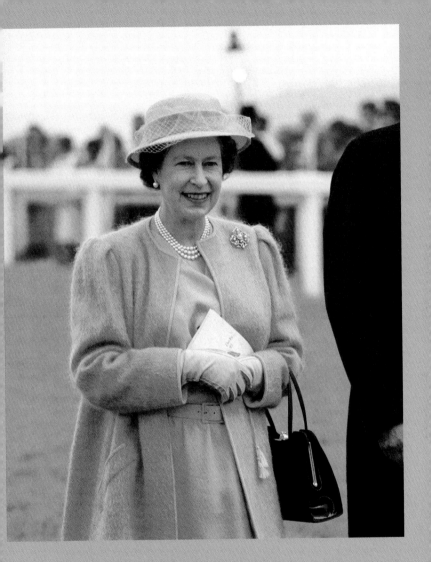

Another Derby Day at Epsom
Racecourse, in June 1985.
The jockeys riding Her Majesty
the Queen's horses wear silks
of gold, purple and red, some of
her favourite colours.

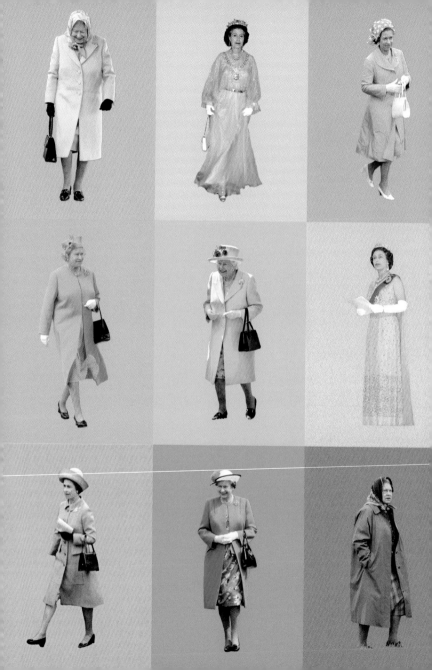

GREEN

The Queen loves every shade of green
– from bottle and British racing to fresh
lime and elegant chartreuse – but is
careful about where she wears it.
She won't attend an engagement
at a grassy venue, like a racecourse
or garden party, in camouflaging green,
but will happily deploy green to stand
out where it's needed. On her official
90th birthday, the Queen went large
in zingy neon lime, while her closest
family surrounded her in respectful
nudes and neutrals.

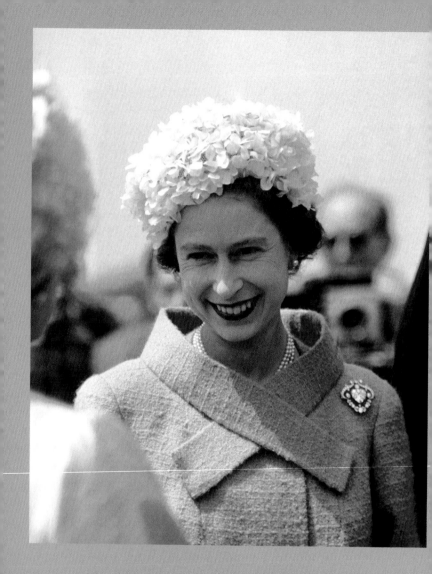

At Epsom Racecourse for Derby Day, 1962, which coincided with her 10-year anniversary as Queen. The white floral cap was a style made famous by actress Elizabeth Taylor, and the pale sage bouclé coat features the signature raised neckline of the period.

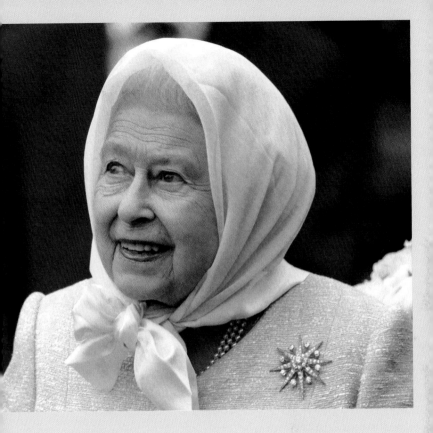

Still working the green, white and diamonds over five decades later in 2016, at a beacon-lighting ceremony in Windsor to celebrate her 90th birthday.

Arriving at the polo at Windsor Great Park in 1973 after a day at Ascot. This silk mint floral hat was designed by milliner Simone Mirman, who responded to the Queen's brief for hats that would 'please photographers', with many soft-brimmed, off-the-face creations scattered with fabric flowers. A number of them were exhibited at the Kensington Palace State Apartments.

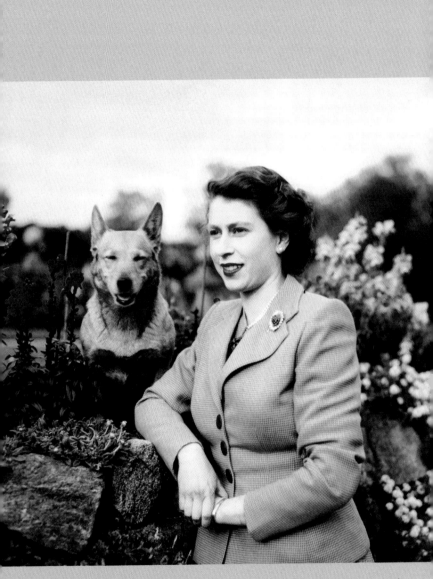

At home with corgi, spring 1953. This is a much softer interpretation of Christian Dior's tailoring so loved by the more fashionable (and extravagant) HRH Princess Margaret.

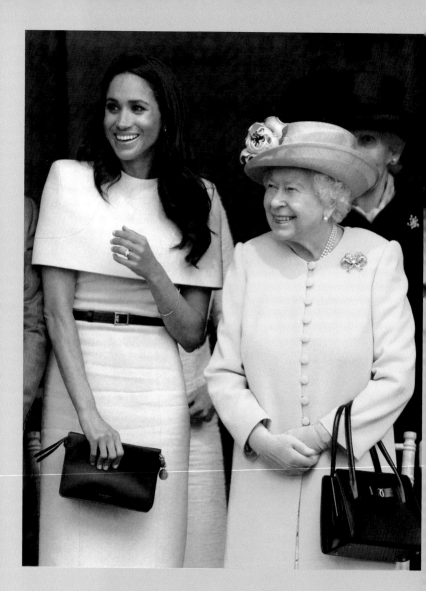

With Meghan, Duchess of Sussex, at the opening of the new Mersey Gateway Bridge in June 2018 – their first public engagement together. The differences between the modern and traditional royal wardrobes are startling – no brooch, hat, sleeves, traditional handbag or gloves for the duchess.

The previous month, at the wedding of Prince Harry to Ms Meghan Markle at St George's Chapel, Windsor Castle. The bride wore Clare Waight Keller, the only female designer at the helm of a major couture house (Givenchy), while the Queen wore this pistachio coat and frock by Stewart Parvin. The embellished hat was made by Angela Kelly, Her Majesty's dresser and closest aide. It has been claimed that their shared laughter is heard frequently by residents at the palace.

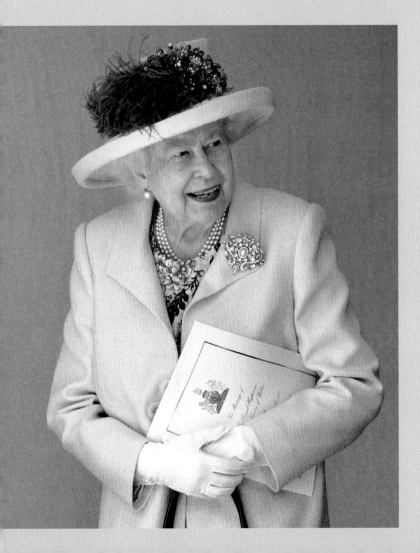

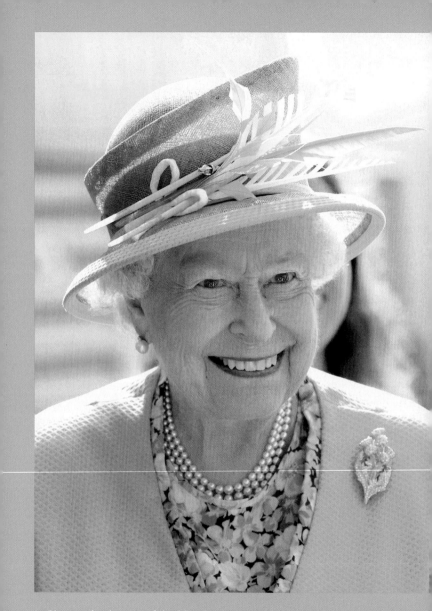

In Glasgow for day one of the 2014 Commonwealth Games. The pin, once again, is a tribute to her host location. 'The Three Thistle Brooch' is an old favourite, and is said to be a gift from the Sultan of Oman.

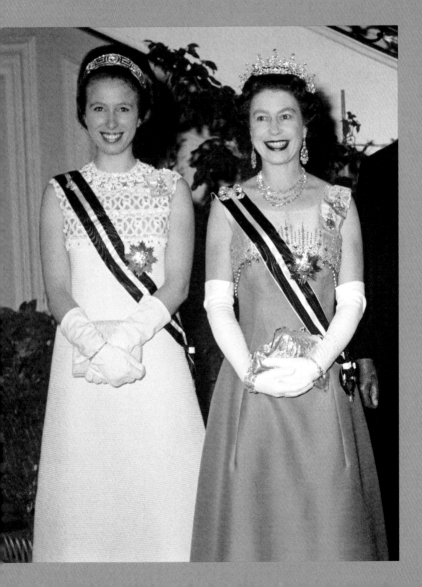

With an as yet unmarried Princess Anne during a 1969 state visit to Austria. It's uncommon for a single woman to wear a jewelled headpiece, traditionally a signal for men not to make their advance.

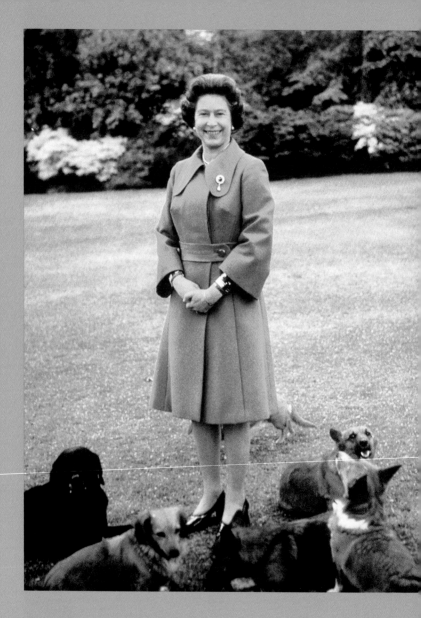

Jade frock coat with oversized Ossie Clark–inspired
collar, accessorised perfectly with a small pack of dogs.

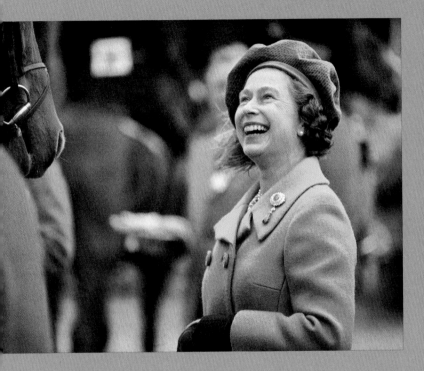

Horses go with everything. Wearing an
emerald wool coat and matching
plumed tam-o'-shanter, to the Royal
Windsor Horse Show, circa 1980.

At a formal event in Canada, August 1976, wearing a print column dress and silver mermaid chainmail bag that made regular appearances for decades.

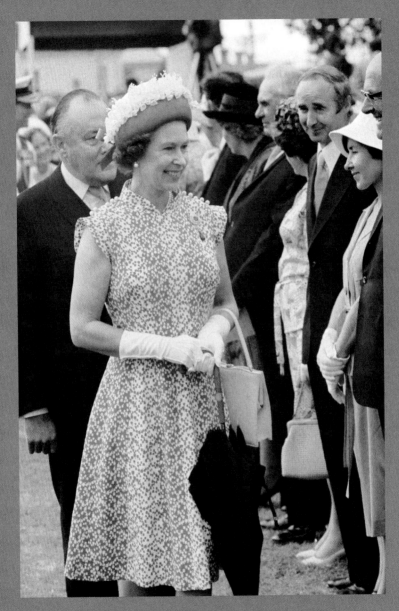

The Queen in cap sleeves – as rare as hen's teeth.
In Fiji during her royal tour, February 1977.

At the Museum of the Adjutant General's Corps in Winchester,
November 2003. The Queen is rarely seen without hats
before 6pm, when women traditionally changed for dinner.
She is particular about brims, which must be narrow enough
for crowds to catch a glimpse of the monarch...

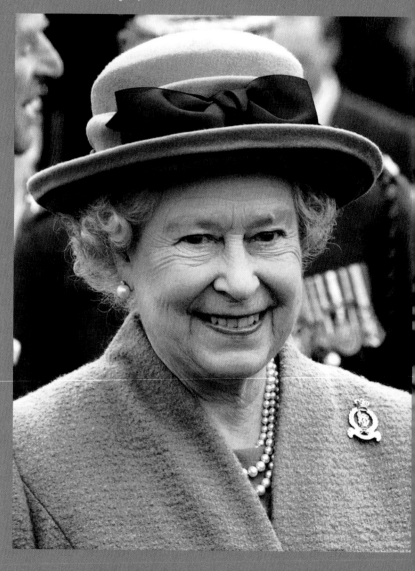

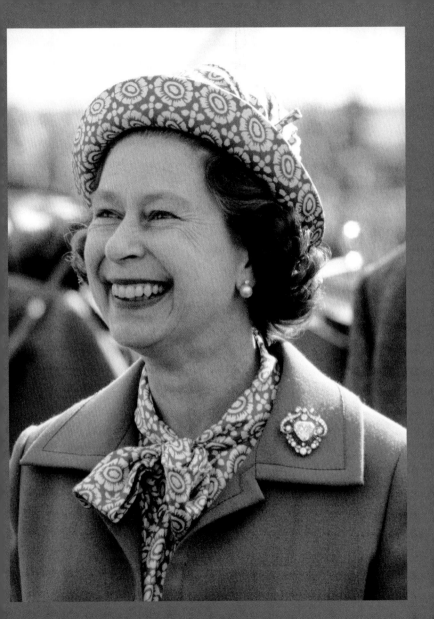

... And for she herself to see clearly – particularly when racing is involved. At The Royal Windsor Horse Show, May 1980.

On the balcony of Government House, Melbourne, March 1954. A rare sighting of the Queen in a double-strand – as opposed to triple-strand – pearl necklace, worn usually by Princess Margaret.

Mother and son in matching tweed. Queen Elizabeth II with Charles, Prince of Wales at Windsor Castle, June 1969.

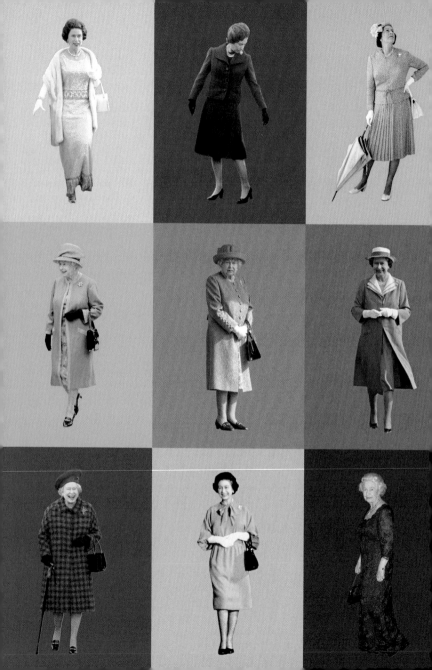

BLUE

Royal blue on the Queen – it's a
no-brainer. But in fact, she has
historically (and especially latterly)
been more likely to wear turquoise,
powder, baby and aqua than the
stronger blues like sapphire, teal and
navy that arguably suit her better.
She rarely wears all three colours
of our national flag – perhaps so as
not to blend in with the sea of flags
from well-wishers, or perhaps
because it's, well, a bit British Airways.

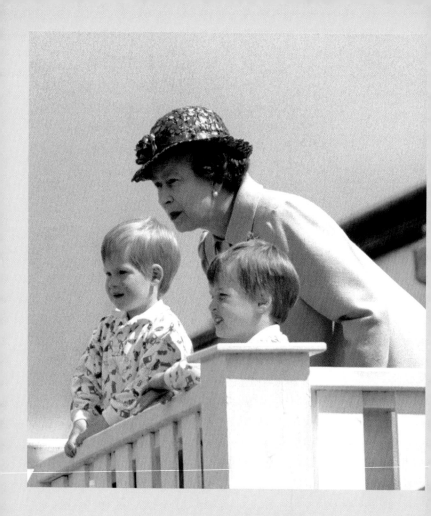

With grandsons Prince Harry and Prince William in
the Royal Box at Guards Polo Club, Windsor, in 1987.
Diana, Princess of Wales, was determined to dress her
children more informally – though the adult princes
have since joked about their childhood exasperation
at her tendency to dress them eccentrically or
exactly alike, as they are here.

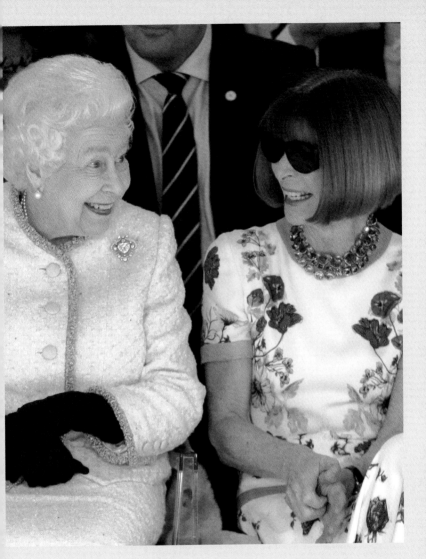

February 2018. Sitting atop a special cushion, next to US *Vogue* editor Anna Wintour at Richard Quinn's catwalk show before presenting him with the inaugural Queen Elizabeth II Award for British Design. This was the Queen's first ever visit to London Fashion Week, and the first time she trended on Instagram and Twitter simultaneously. It seems unlikely that QEII would have approved of Wintour's refusal to remove her iconic sunglasses throughout.

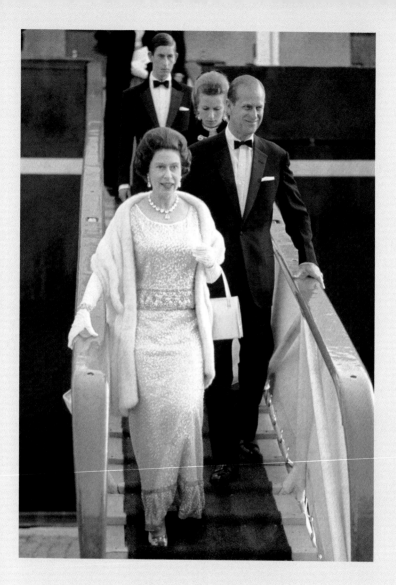

Leading Prince Philip, Princess Anne and Prince Charles off HMY *Britannia* prior to a banquet during a royal visit to Norway in August 1969. A rare instance of the Queen's bag (white) not matching her shoes (silver). It may have been decided that a metallic handbag atop diamonds, fur and a beaded shift would be a step too far.

Something blue. At the wedding of Princess Eugenie of York and Jack Brooksbank at Windsor in October 2018. Wearing her favourite black Launer bag and a powder-blue ensemble by her dresser Angela Kelly.

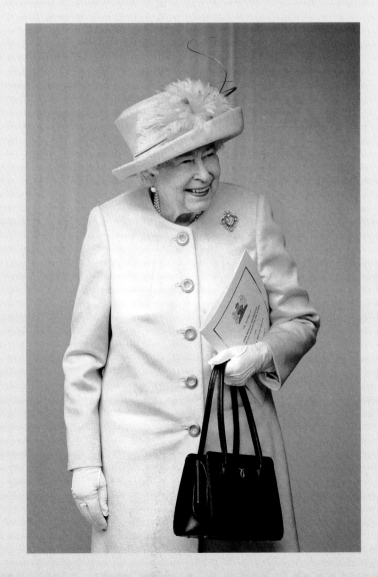

Queen Elizabeth II and Prince Philip around their diamond wedding anniversary in November 2007. The Queen is mostly seen in triple-strand pearl necklaces, and has made them her trademark since 1935, when George V gave his two granddaughters a pearl necklace each – a double strand for Margaret, a triple strand for Lilibet.

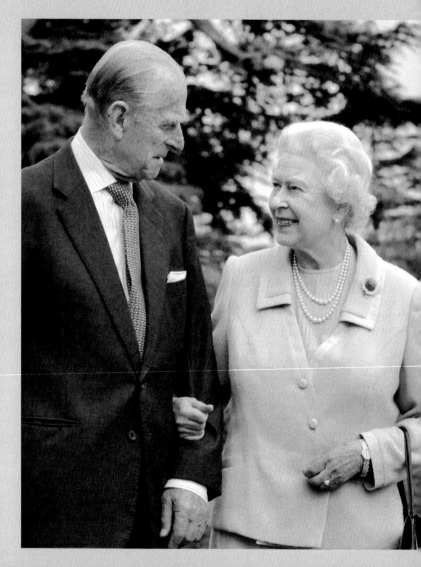

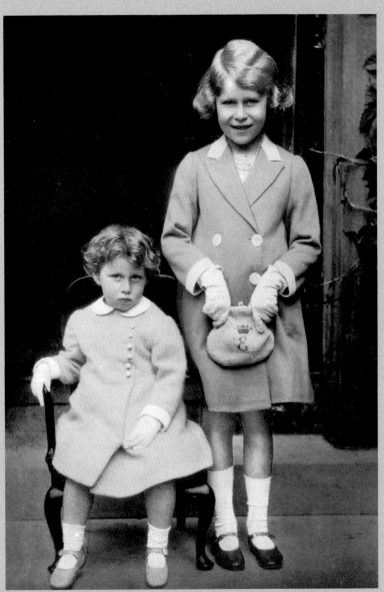

Princess Margaret and Princess Elizabeth, the royal sisters, sometime in the 1930s.

In New Zealand, spring 1977, proving one can never over-accessorise. QEII has always worn shades to avoid unsightly squinting. Nowadays, she wears modern transition lenses in her regular specs.

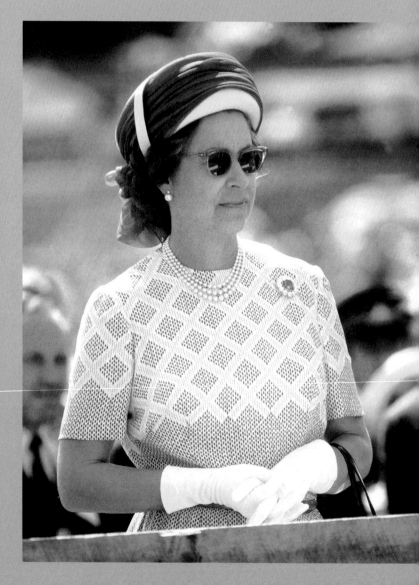

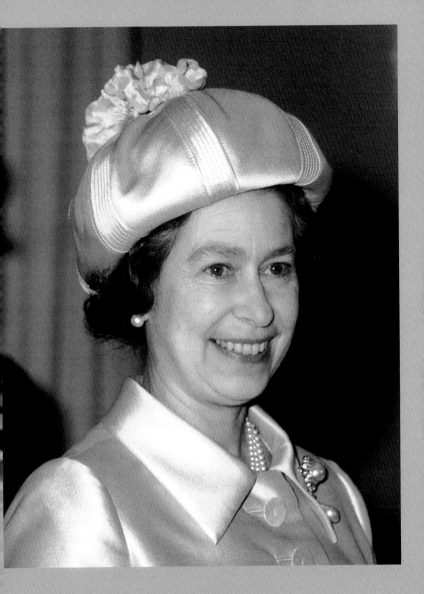

1979. In a powder-blue satin frock coat and embellished tam-o'-shanter reminiscent of a jockey's cap.

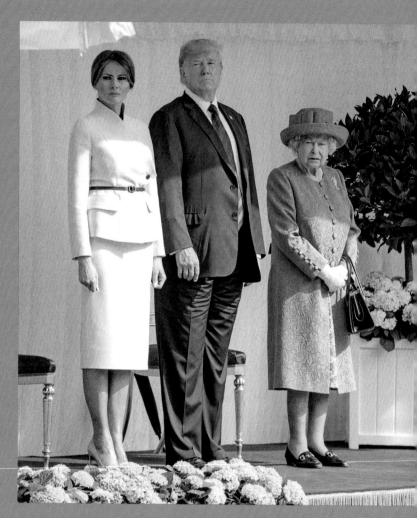

July 2018. With US President Donald Trump and First Lady Melania in the quadrangle of Windsor Castle. There has been much speculation over the Queen's choice of jewellery for the controversial visit. Blogger Samurai Knitter revealed that on day one of Trump's visit, the Queen wore a simple brooch personally gifted by the Obamas to signify their friendship. On the second day, she wore another given to her by Canada, with whom Trump has a frosty relationship. On the last day, she wore a brooch she'd barely worn since the funeral of her father, George VI. This might seem a conspiracy theory too far, were it not for the fact that the Queen is known to have matched her brooches thematically throughout her entire reign.

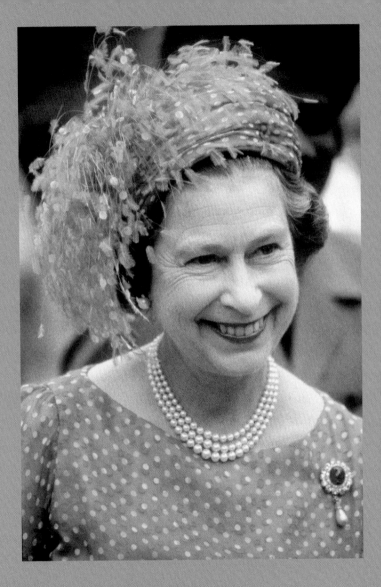

Cornflower blue and polka dots during her official tour of the South Pacific, October 1982. The feathered hat is by milliner Frederick Fox and the sapphire, diamond and pearl brooch belonged to Empress Marie Feodorovna of Russia.

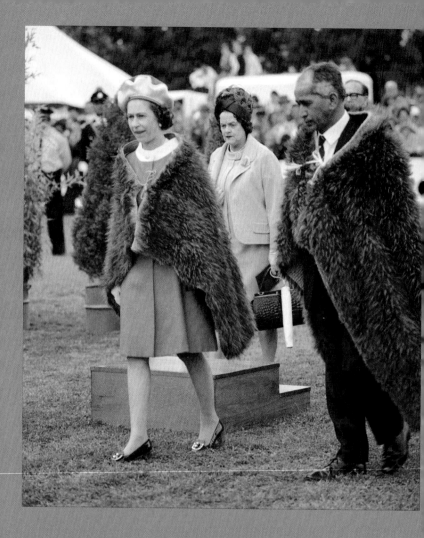

Wearing a traditional Maori kiwi-feather cloak
during her jubilee tour of New Zealand, 1977.
The Queen took such a liking to the cloak
(given to her in January 1954) that she's worn
it on several subsequent visits. The kiwi bird
has huge significance in Maori culture
and represents protective spirits.

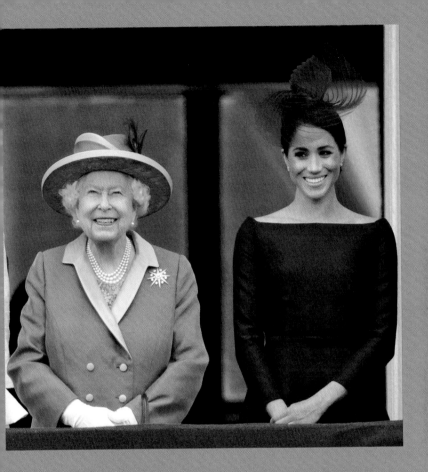

With Meghan, Duchess of Sussex, watching the RAF fly past on the balcony of Buckingham Palace, to mark the RAF centenary in July 2018. It's no coincidence that the Queen has chosen to wear azure, the colour of the original RAF uniforms, inspired by the open sky. Meghan also wears blue in honour of the air force.

Another tribute in colour. Meeting British Airways
dignitaries at Heathrow Airport in London, May
2004, to mark the 10th anniversary of UNICEF and
British Airways' Change for Good coin-collecting
programme, wearing a hat and coat in cyan blue –
the official colour of UNICEF.

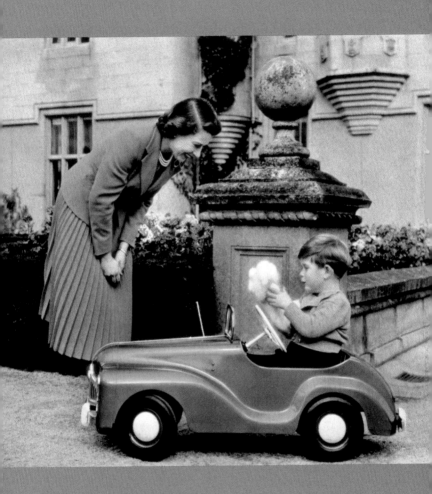

Matching one's toy sports car to
one's sunbeam pleats – a gesture
to which all busy mothers can
surely relate. Balmoral Castle, 1952.

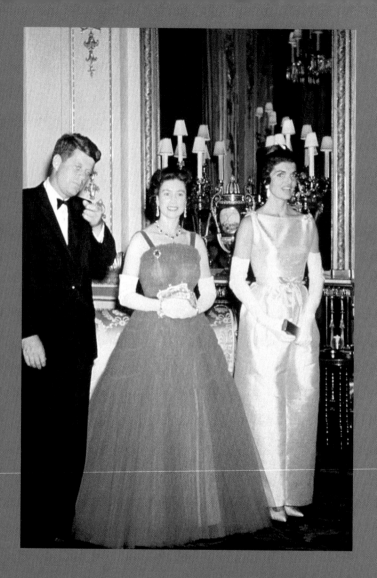

President John F. Kennedy and First Lady Jackie Kennedy attend a private dinner at Buckingham Palace in June 1961. The meeting was tense, since Jackie had invited her sister and twice-divorced brother-in-law. The Queen objected, and the First Lady objected to her objection. A perfect start to a relaxing evening.

In Saudi Arabia, spring 1979. The Queen respects local dress codes and cultures, here by covering her head, limbs and neck in a silk chiffon turban hat by Frederick Fox, long scarf (firmly anchored by sapphire brooch), and floor-length royal blue seersucker suit by Hardy Amies. This ensemble is now part of the Royal Collection.

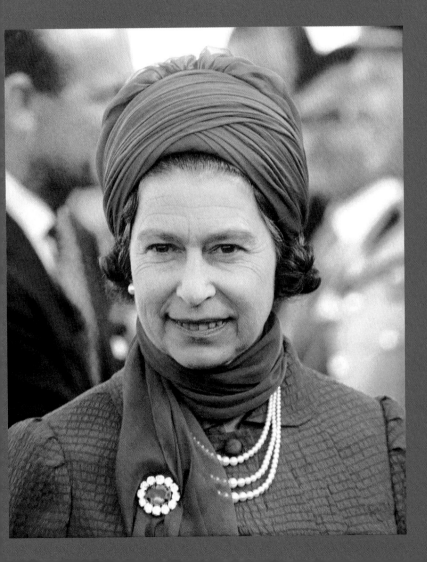

With her two eldest children, Charles and Anne, at Balmoral, 1952. Custom dictates that royal children must be dressed formally when in public, though it's highly unusual for a male royal to be seen in long trousers before the age of eight (Charles is four here).

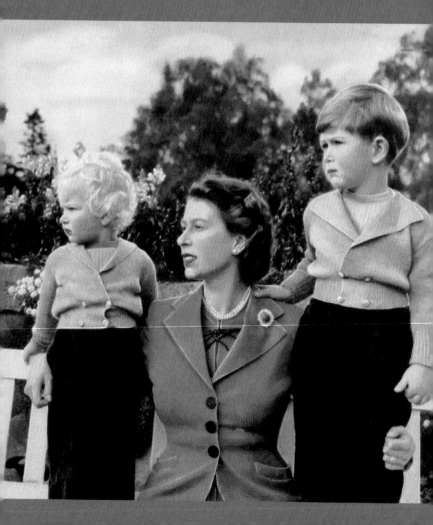

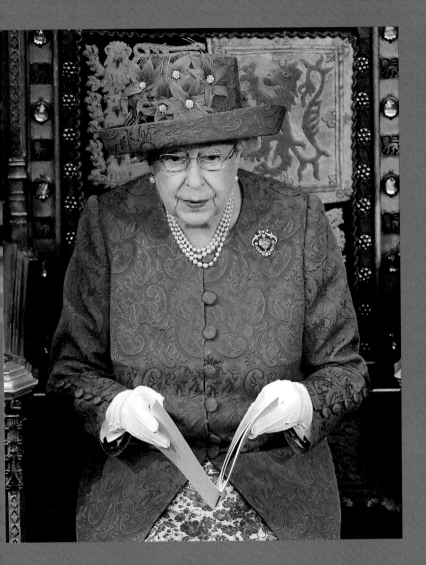

June 2017. What does one wear to the State Opening of Parliament almost a year to the day after the country's referendum on Brexit, a ceremony delayed after Theresa May's government lost its majority? EU blue and gold with a smattering of stars, of course. A 'coincidence' as sublime as it is unlikely. Naturally, the Palace offered no comment.

Attending a service for the Order of St Michael and St George at St Paul's Cathedral, July 1968. On her satin cape, the Queen is wearing the Star of the Order, which bears the motto 'Auspicium Melioris Aevi', meaning 'Token of a better age'.

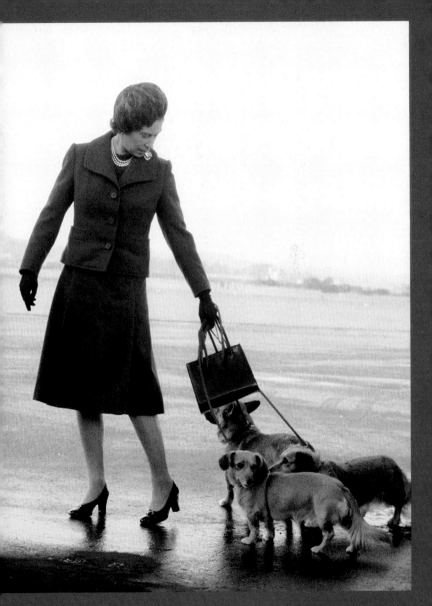

In a teal tweed suit and feathered hat, at Aberdeen Airport in 1974. The striking scarlet dog leads will be no happy accident.

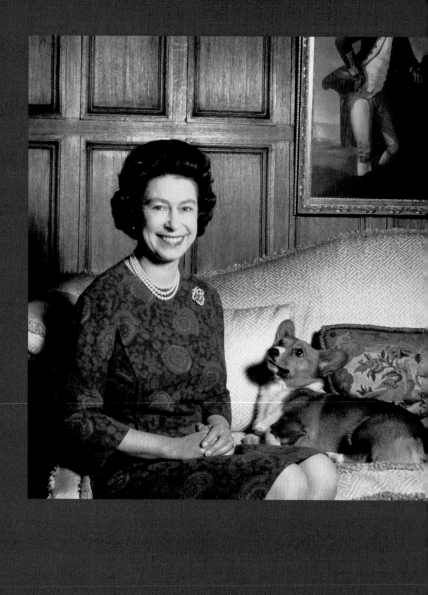

At Sandringham in 1970 with whichever of the Queen's many devoted corgis looked most fetching next to indigo paisley.

On day one of the Royal Windsor Horse Show in May 2017 in her preferred country garb – navy quilted David Barry jacket and Hermès headscarf. Country kilt and sturdy flat Oxford shoes not seen.

PURPLE

'When I am an old woman I shall wear purple,' said poet Jenny Joseph, and the Queen apparently had similar intentions. Elizabeth has worn this, the most regal of colours, more often as she's advanced in years, but purple has been associated with the monarchy for centuries – Queen Elizabeth I forbade anyone but senior members of the royal family to wear it. Her modern namesake loves lavender and lilac, but in recent years has been more likely to embrace bold magenta, strong purples and almost fluorescent ultraviolet.

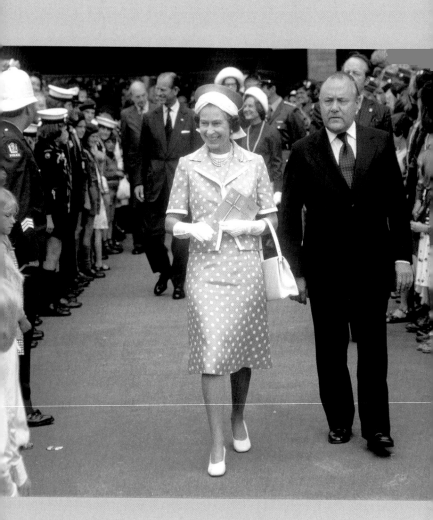

In cheerful lilac polka dots, accompanying
a less chipper Prime Minister Muldoon on a
walkabout in Wellington, New Zealand, 1977.

With father of the bride, Mr Rhys-Jones, followed by Prince Philip and Mrs Rhys-Jones at the early-evening civil wedding of Prince Edward to Sophie Rhys-Jones in Windsor. The Queen adhered to the unorthodox dress code of evening wear and no hats (this is a Frederick Fox feather fascinator worn with Hardy Amies gown). The Queen Mother, who was seldom seen hatless, did not.

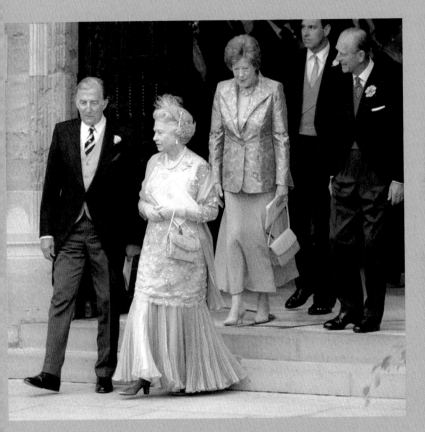

Inspecting troops during a visit to Howe Barracks in Canterbury, June 2013.

Rumoured contents of the Queen's handbag:

small camera

family photos

compact and lipstick (usually pink, by Clarins or Elizabeth Arden)

suction-mounted bag hook, for hanging bag from tables

ironed and folded bank note for any church service collections

crossword clipped from newspaper for any idle moments

mints...

...reading glasses

fountain pen

small silver make-up case given to her by Prince Philip shortly after they were married

a mobile phone for calls to grandchildren.

Aboard the Trinity House Vessel *Galatea*, a buoy and lighthouse maintenance vessel, moored on the Thames in London, October 2007.

Visiting Ipoh, Malaysia, in October 1989, when leg-of-mutton sleeves and self-belt knee-length tulip dresses were a British mum staple.

Pastels and black to open the Millennium Bridge Walkway across the River Thames, London, May 2000.

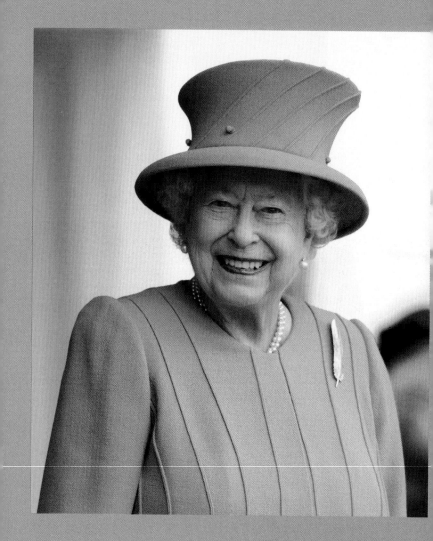

Attending the 2016 Braemar Highland Gathering at the Princess Royal and Duke of Fife Memorial Park in Scotland. There has been an annual gathering at Braemar for over 900 years. The current gathering is in the form of Highland games and takes place on the first Saturday in September. This feather brooch (a nod to the Scottish native golden eagle) was given to the Queen by the Braemar Royal Highland Society for her Golden Jubilee in 2002, and she has worn it to each gathering since.

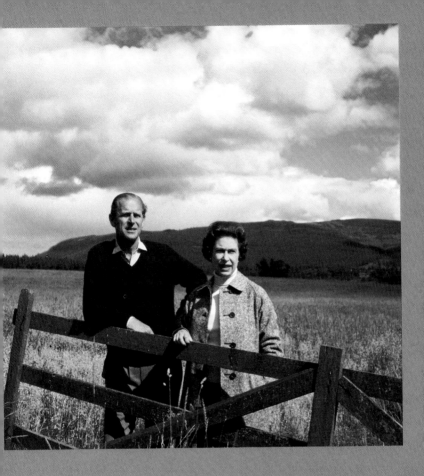

With Prince Philip at Balmoral,
wearing casual tweeds and warm
jumpers, in 1972. The Queen is said
to be at her happiest and most
comfortable in the countryside.

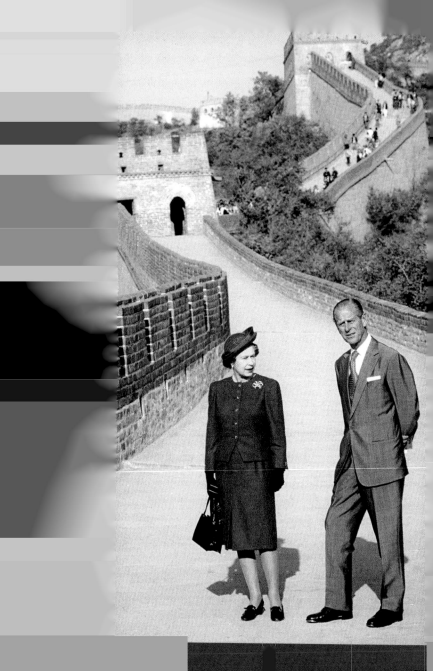

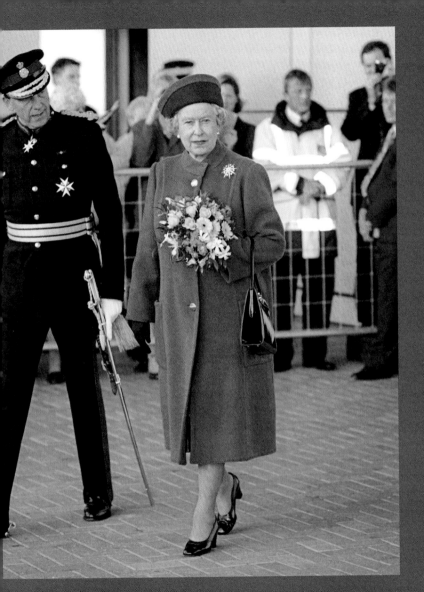

At Luton Airport, November 1999, for the opening of a new terminal. The brooch is known as the Jardine Star and was left to the Queen in 1981 by Lady Jardine of Scotland. She seldom wore it until the latter half of the 1990s, when it became a firm favourite.

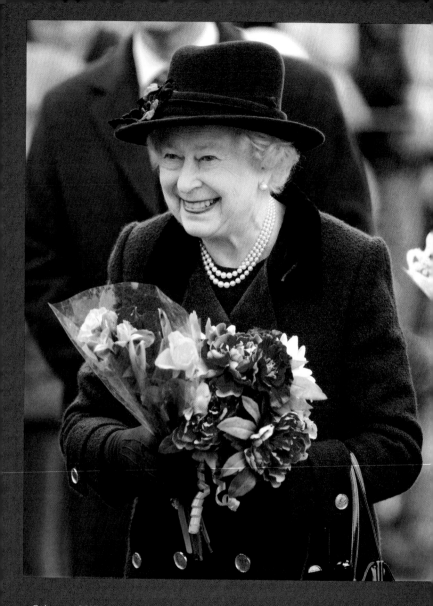

February 2013. Holding bunches of flowers given to her during a walkabout after attending service at the church of St Peter and St Paul in West Newton.

Arriving at King's Lynn station, after taking the train from London to begin her Christmas 2017 break at Sandringham. The Queen almost always escapes to the countryside in a headscarf.

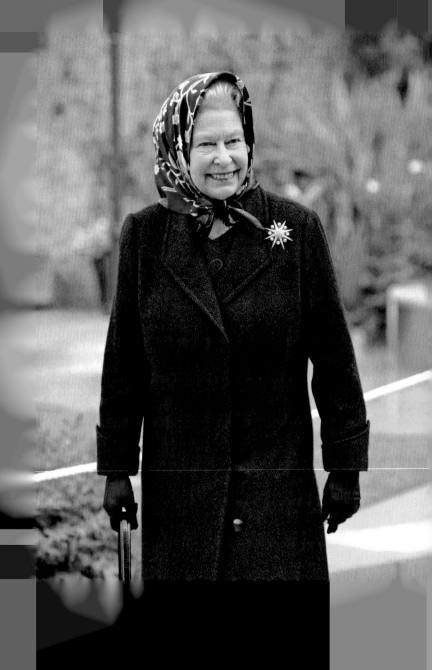

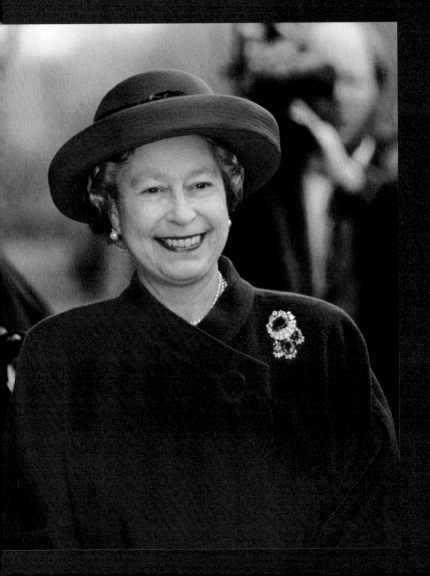

Visiting the village of Snettisham near Sandringham on the 40th anniversary of her accession to the throne, February 1992 (two years after the Queen stopped dyeing her grey hair altogether).

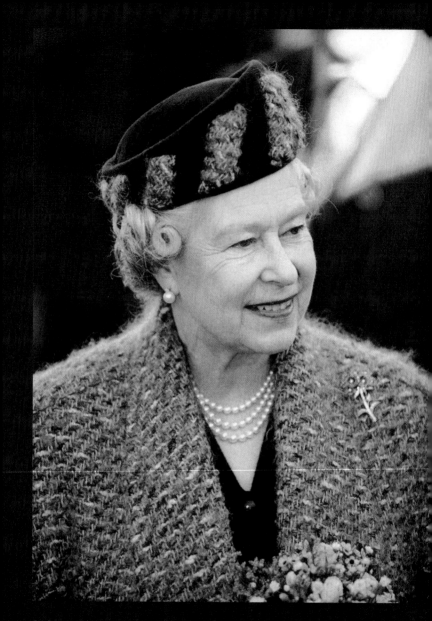

A visit to Kent, November 1994. The Queen's ears were pierced in 1951, at age 25, four years after being gifted Cartier pierced earrings by her parents.

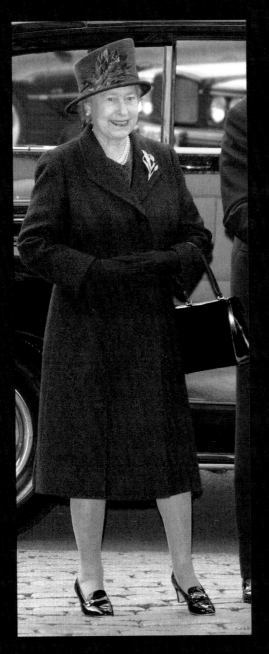

At Westminster Abbey to attend the Commonwealth Day Observance, 2003. These favourite patent character shoes, like almost all of the Queen's footwear, are handmade by Anello & Davide. HRH reportedly calls this style 'my work shoes'.

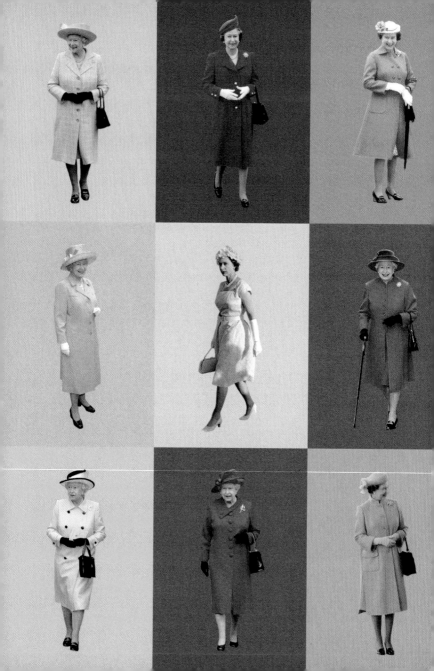

PINK

What was once her favourite and most flattering colour has more recently become a rarer treat. All pinks, from soft blancmange and washed-out salmon to bright bubblegum and bold cerise, look terrific on the Queen, but latterly she has mainly opted for fuchsia and barely-there pastel pink. What has remained constant is her signature pink lipstick – scarcely altered since her late teens.

Princess Elizabeth was an early adopter of pink and red worn together – a most modern of colour combinations. Here the newly engaged Queen-to-be stands in Buckingham Palace's State Apartments, wearing soft, drapey blush pink, and crimson lipstick (July 1947).

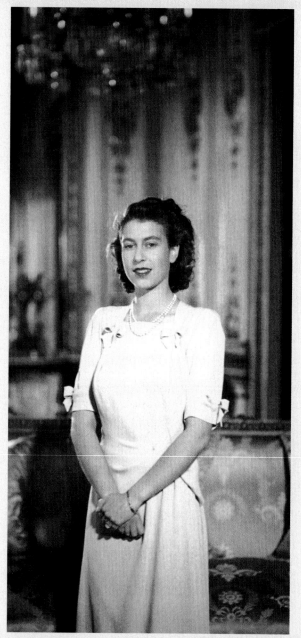

'Pink is the navy blue of India,' said legendary fashion editor Diana Vreeland. And Queen Elizabeth II's 1961 tour of India included plenty of it – here she is in Bombay, bedecked in pink spots, beads and blooms.

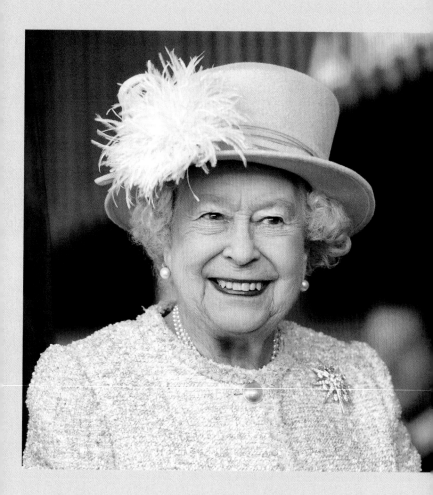

At Chichester Theatre, November 2017, in her favourite pink lipstick. The Queen has a rather outré habit of reapplying her lipstick at the lunch table or theatre seat. She reportedly reassured former US First Lady Laura Bush that this was perfectly acceptable.

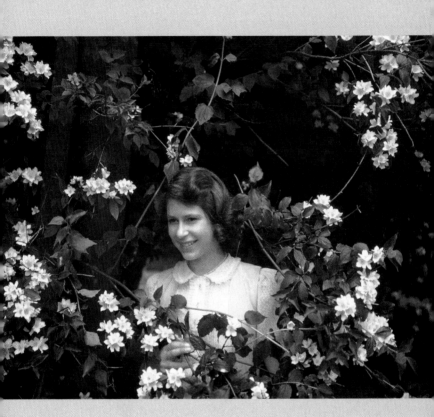

Princess Elizabeth in July 1941 in a syringa bush in the grounds of Windsor Castle. She had just begun to wear make-up, after (Oscar Wilde's daughter-in-law) Thelma Holland of Cyclax cosmetics approached the princess with an offer of beauty advice. She became the future Queen's cosmetician, guiding her through her wedding, coronation and royal duties.

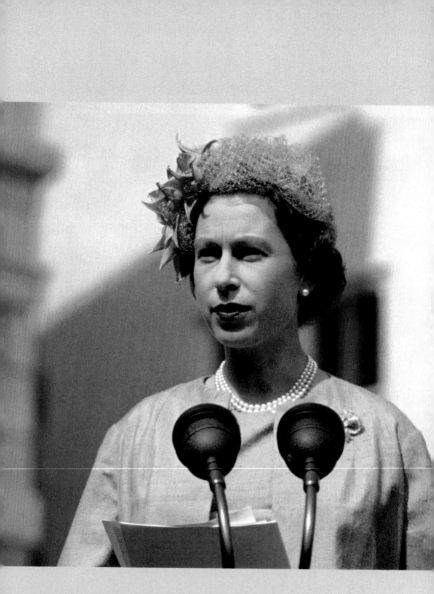

In May 1961, at the inaugural ceremony for the Improvement Scheme, in Windsor. The Queen is wearing shantung silk. This and all the monarch's outfits are tested for creasability by being squeezed, wrung and packed tight. Garments that fail the test are rejected.

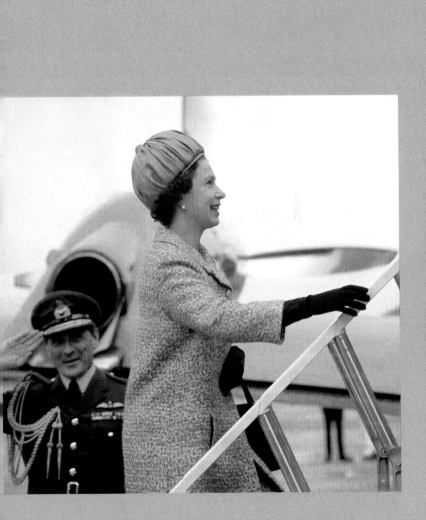

Boarding a plane to fly to Scotland on a provincial tour, May 1969. Similarities between First Lady Jackie Kennedy's airstrip appearance in pink bouclé Chanel suit and pillbox are surprising but undeniable.

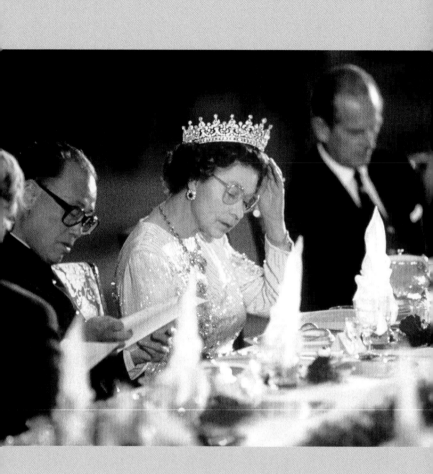

Peking, October 1986. The Queen adjusts her tiara
(named, rather incongruously, 'Girls of Great Britain
and Ireland' and passed down by Queen Mary of Teck)
while perusing the menu at a banquet held in
her honour. One may eat in a tiara, but never –
not even canapés and finger foods – in a hat.

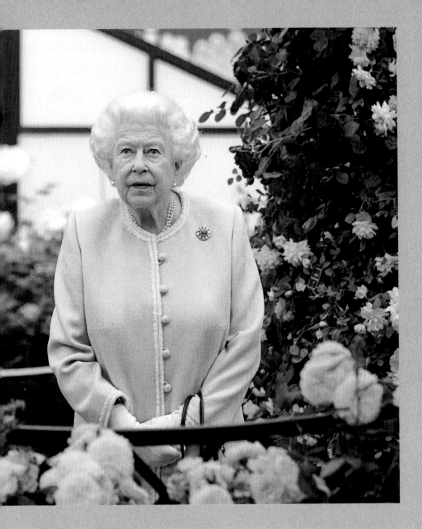

Admiring a display of roses at the 2018 Chelsea Flower Show at the Royal Hospital grounds, London. The Queen's hair is now pearl white, matching her favourite jewellery, which includes this pink flower brooch – no doubt a nod to the event.

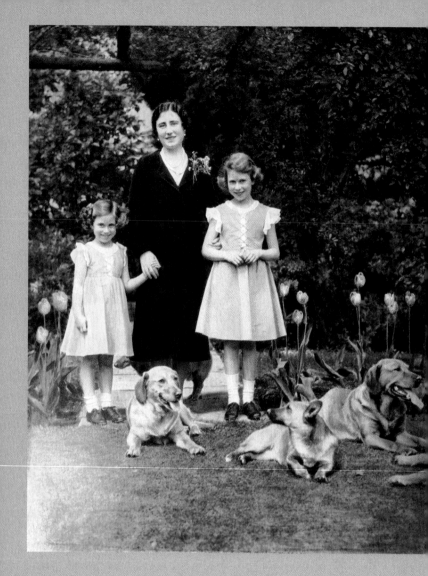

The then Duchess of York with her daughters Princesses Elizabeth and Margaret, wearing matching elfin frocks, in the garden of the Royal Lodge at Windsor.

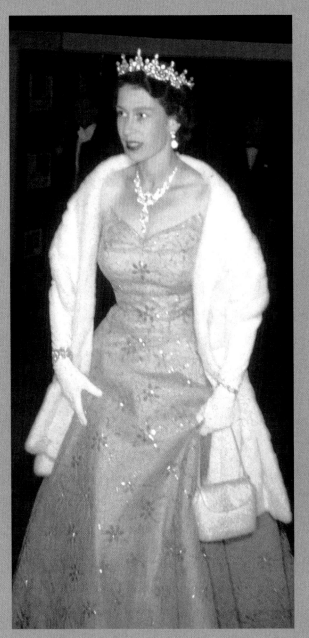

On a 1951 visit to her beloved Mediterranean island of Malta. The glittery, corseted pink gown was designed by Hardy Amies, and was seen as a tad 'racy' by journalists at the time.

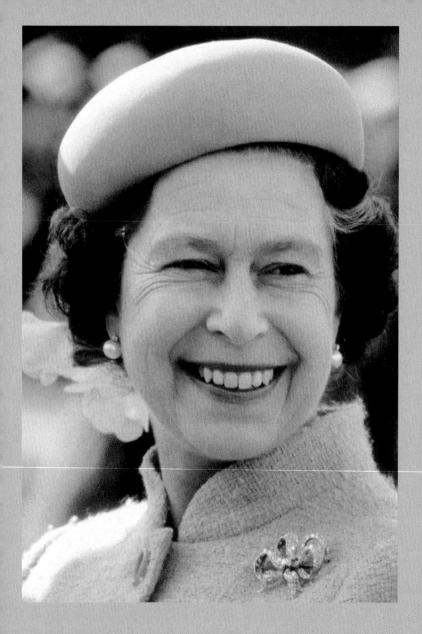

In January 1979, proving that everyone is flattered by coral pink.

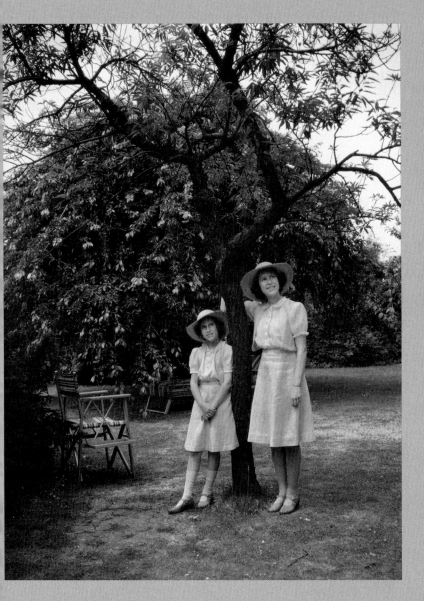

More wardrobe twinning for young Princesses Elizabeth
and Margaret, seen here in the garden at Windsor.
Their styles were soon to become quite different.

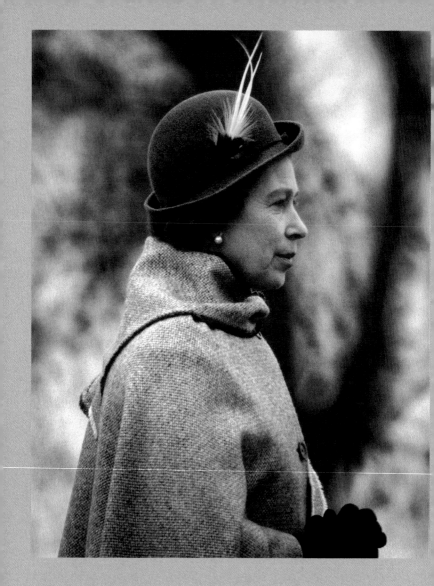

Here she wears a pink cape and red hat with feathers as she attends the Royal Windsor Horse Show in 1979.

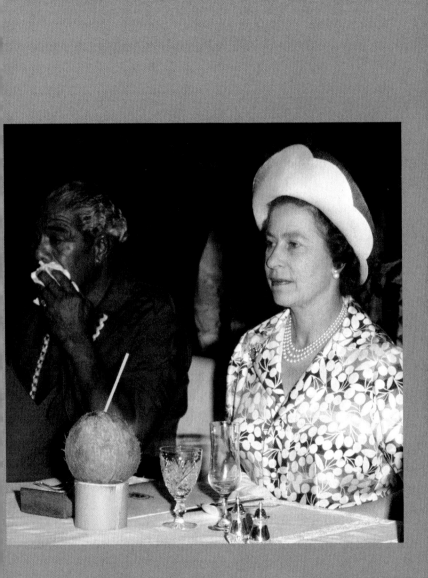

The Queen studies her coconut drink as she attends a traditional Western Samoan feast in February 1977. It's unlikely the straw hat would have remained in place after food was served, depending on local customs.

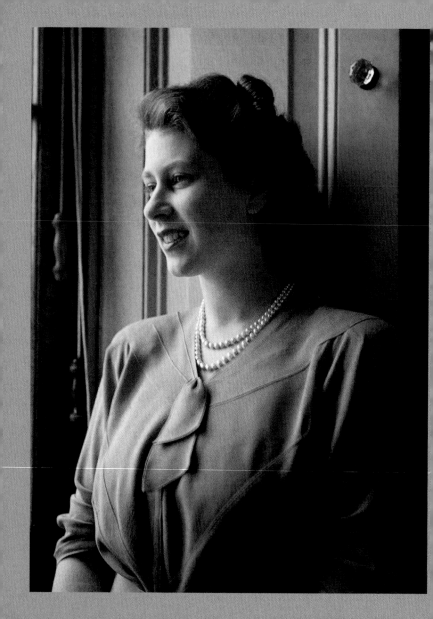

Princess Elizabeth, aged 20, in dusky rose soft
tailoring and pin-curls, at Buckingham Palace.

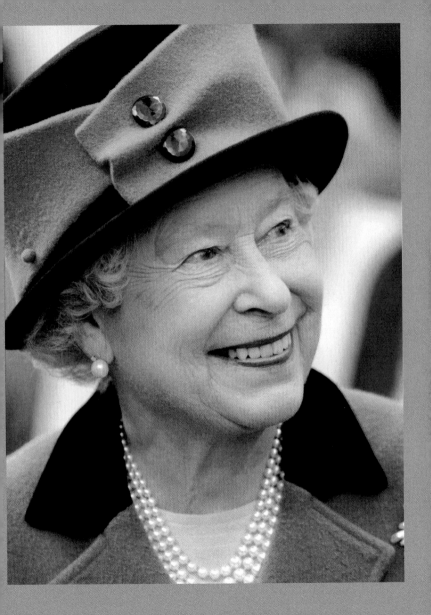

March 2007. Dressed boldly in pink to meet locals during a walkabout in Brighton, Britain's unofficial gay capital.

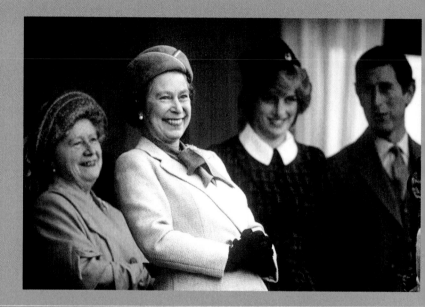

With the Queen Mother, and new parents Princess
Diana and Prince Charles at the 1982 Braemar Gathering,
where hats for women are customary. Princess Diana
all but abandoned hats when she observed that one
couldn't cuddle a sick child while wearing one.

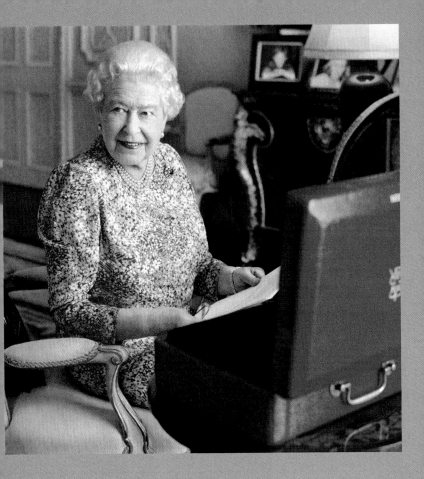

September 2015. The Palace appoints Mary McCartney (daughter of Sir Paul) to photograph the Queen as she becomes Britain's longest reigning monarch. The image shows her seated at the desk in her private audience room at Buckingham Palace. She has taken receipt of the official red box on almost every day of her reign. It contains important papers from government ministers in the United Kingdom and her Realms and those from her representatives across the Commonwealth and beyond. Its bright orangey crimson also looks tremendous against pink, and there's no use denying it.

At Ventnor during a royal visit to the Isle of Wight, matching salmony coral lipstick, hat and coat, July 1965.

Mixing wintry textures of magenta velvet and bouclé wool at the Old Comrades' Parade at the Cavalry Memorial in Hyde Park, May 1995.

NEUTRALS

'I can't wear beige because nobody would know who I am,' Queen Elizabeth II reportedly once said. Despite her love of bold colour and disdain for biscuity hues, she has nonetheless on occasion drawn from a palette of neutrals. Traditional trenches, camel coats, country tweeds, sober grey suits, cream satin ballgowns and, of course, the virginal white lace Norman Hartnell wedding dress and its 13-foot train – QEII is at least semi-hooked on classics.

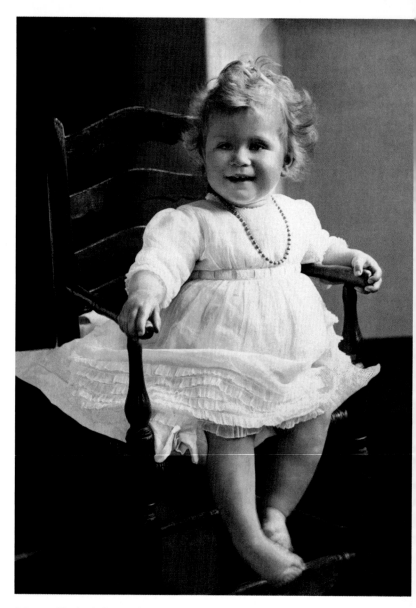

Princess Elizabeth (known by family members as 'Lilibet')
as a toddler in white silk Georgette and beads.

20 November 1947. Ready for her wedding to Philip, Duke of Edinburgh at Westminster Abbey. The gown was designed by Norman Hartnell, and bought using 200 extra clothing ration coupons from the government. Her 'something borrowed' came in the form of a tiara, once belonging to Queen Mary of Teck, loaned to the princess for the day.

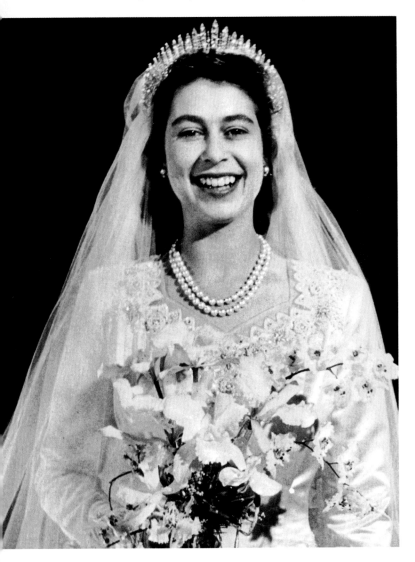

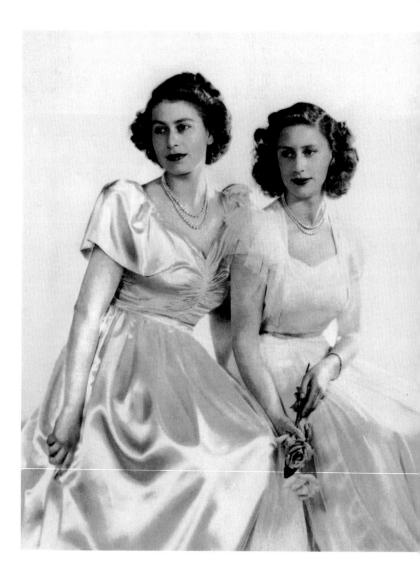

Princess Elizabeth and Princess Margaret were sometimes called 'the debutante princesses', but in fact were no such thing. The Queen ultimately abolished the ritual of presenting aristocratic and unmarried young women to the monarch at court. The Duke of Edinburgh allegedly dismissed the whole tradition as 'bloody daft' and Princess Margaret said, 'We had to stop it really, every tart in London was getting in.'

Queen Elizabeth II inherited much of her jewellery from Queen Mary of Teck. Here, in May 1965, she wears her late paternal grandmother's jubilee necklace and a diamond bow pearl drop brooch to a state reception in Bruhl, Germany.

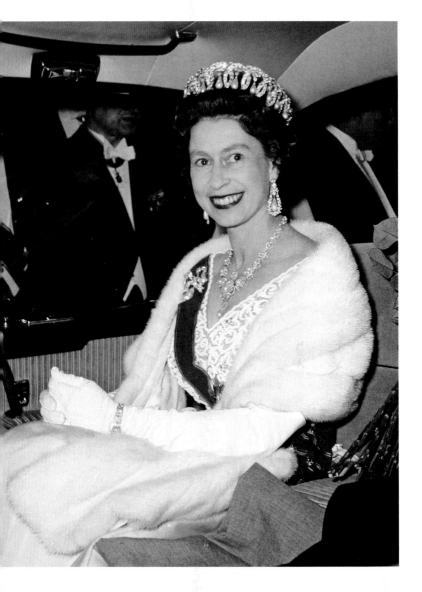

When is a neutral not really a neutral? When piped in thick scarlet, probably. Attending a polo match at Windsor Great Park after attending Royal Ascot in June 1976.

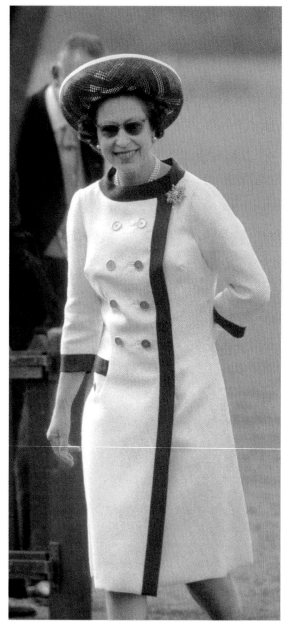

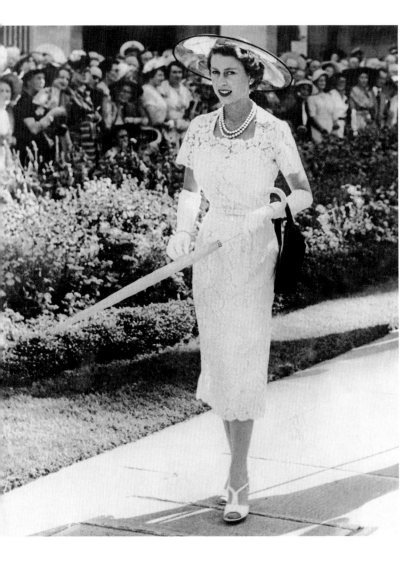

In a slim-fitting white lace dress and parasol at a
Sydney garden party in 1954 – some 30 years
before Italian design duo Dolce & Gabbana
made near identical frocks their signature.

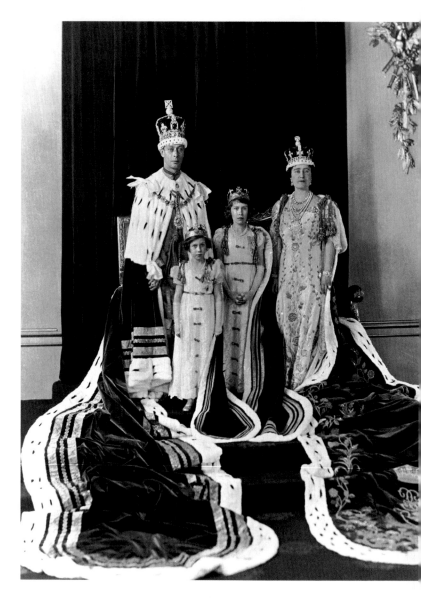

Not suitable for vegans: King George VI and Queen Elizabeth with their daughters Princess Elizabeth and Princess Margaret, swathed in ermine coronation robes from Ede & Ravenscroft.

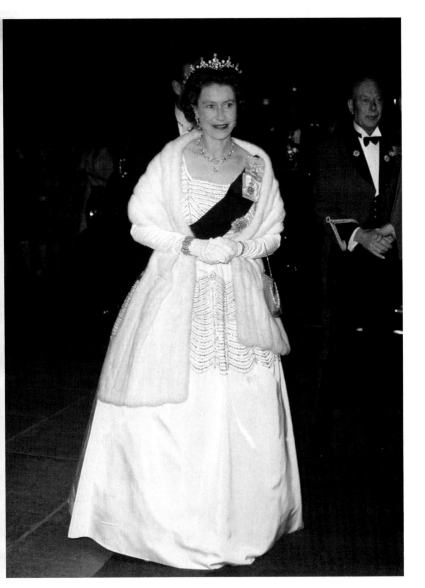

Attending a 1960 film premiere wearing a white beaded evening gown by Norman Hartnell, who also designed wedding dresses for both Princess Elizabeth and Princess Margaret.

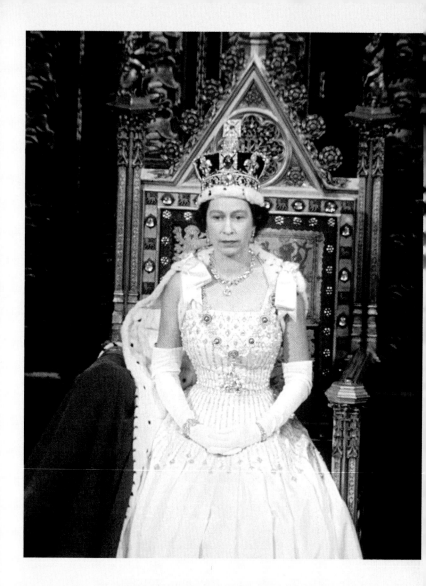

During the 1967 State Opening of Parliament. The Queen has worn a crown every year except 1974 and 2017 when (on each occasion, owing to schedule disruption relating to a general election) she abandoned the crown and robes of state in favour of simpler opening ceremonies requiring little preparation.

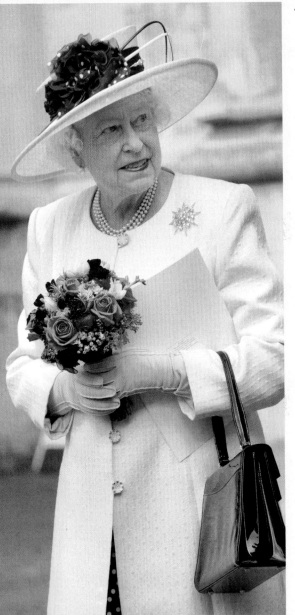

Attending a service of celebration to mark the 400th anniversary of the King James Bible at Westminster Abbey. Most Launer handbags are named after operas – Tosca, Juliet, Susanna, Maddalena, Lulu and the Queen's personal favourite and most-used handbag, the Traviata. All are handmade, and for the Queen the suede lining is replaced by silk for a lighter carriage.

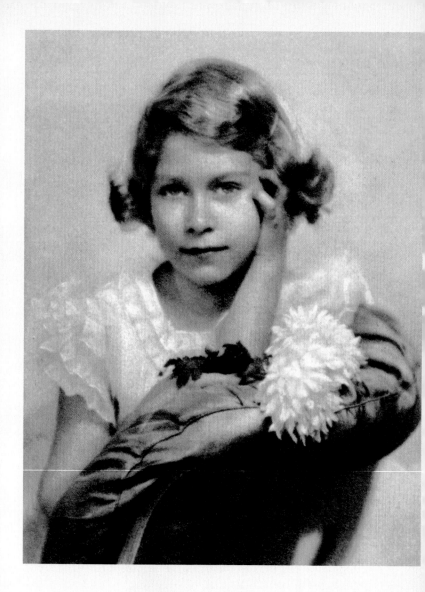

Aged nine in 1935, at home in London, before discovering a love of bold, cheerful colour.

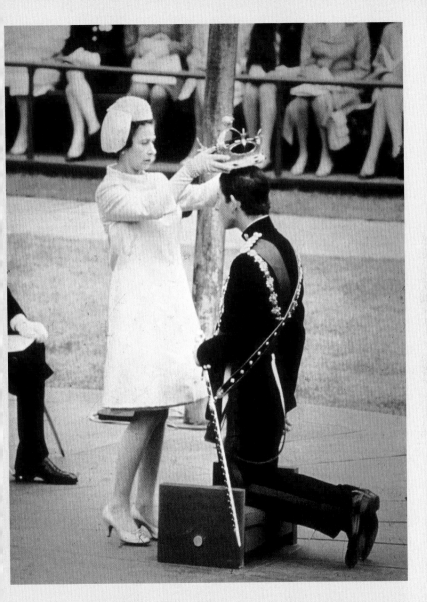

Crowning her son Charles, Prince of Wales, during his 1969 investiture ceremony at Caernarvon Castle. Members of the royal household are required to personally 'wear in' the Queen's new shoes in advance of her performing royal duties in them.

Recording her 2012 Christmas message to the Commonwealth in 3D for the first time ever, which may account for the futuristic fabric of this shimmering tunic. Or perhaps the Queen was characteristically colour-blocking to match the White Drawing Room at Buckingham Palace, where filming took place.

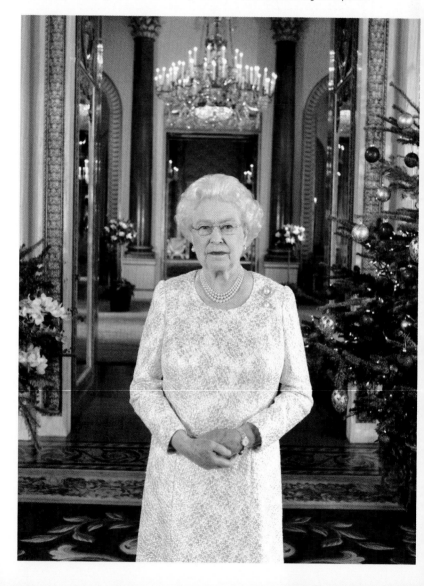

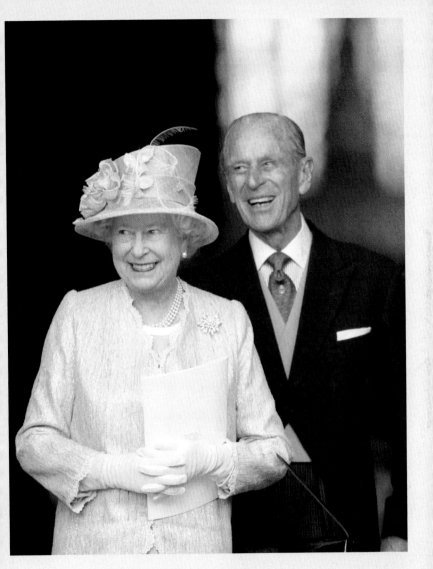

Champagne – why not? Sparkling ivory with the Duke of Edinburgh at St Paul's Cathedral for a service of thanksgiving in honour of the Queen's 80th birthday, June 2006. Hat by Rachel Trevor-Morgan.

Joining the Boyfriend Shirt trend while watching her husband compete at the Royal Windsor Horse Show, May 1998.

Circa 1985: with the Queen Mother and attempting to blend in during the Badminton Horse Trials. Riding boots are generally worn only in the countryside, or with military uniform.

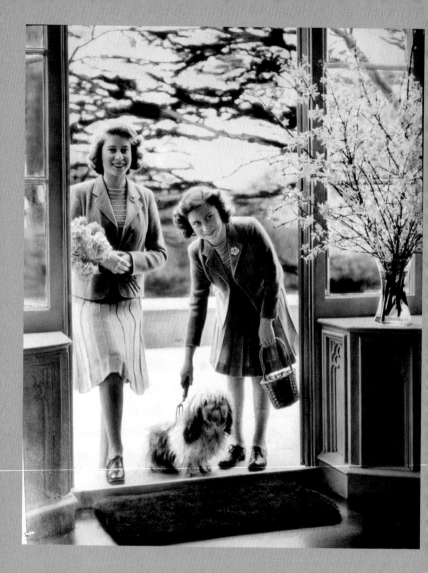

Princesses Elizabeth and Margaret dressed entirely in autumnal tones, their Lhaso apso dog notwithstanding, outside the Royal Lodge, Windsor, April 1942. They dressed either identically or similarly until early adulthood.

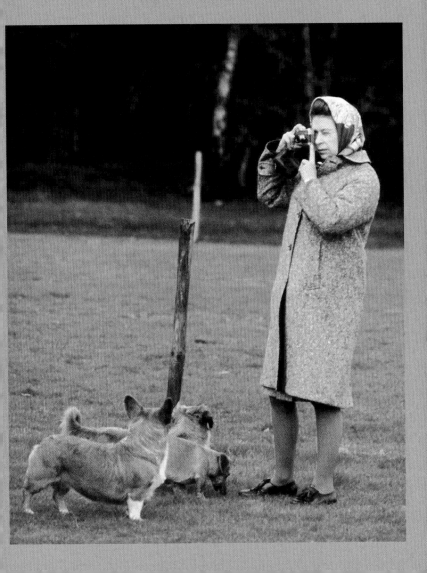

At Windsor Park, 1960. Queen Elizabeth II is known to enjoy taking photographs, particularly those of her animals.

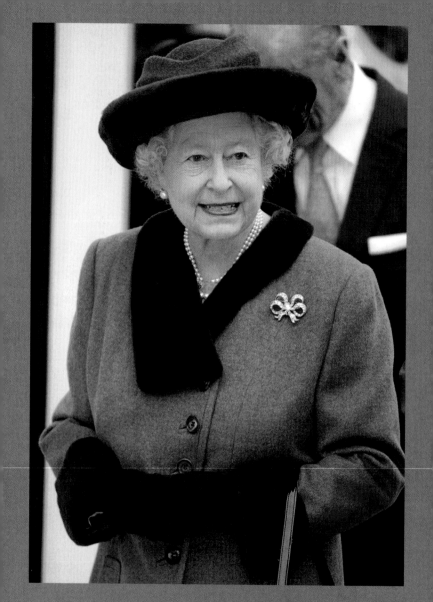

Opening the King Edward Court Shopping Centre in
Windsor, February 2008. One of only a handful of occasions
the Queen has attended a formal engagement in brown.

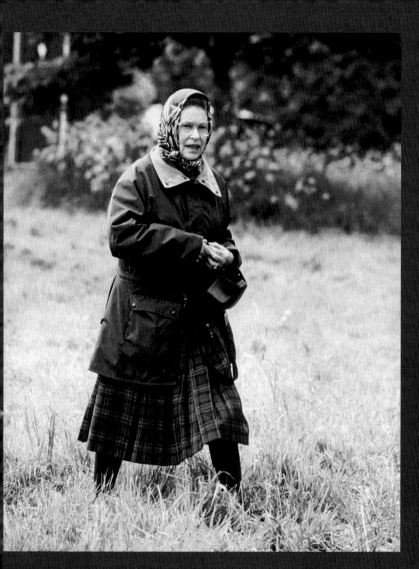

At the Royal Windsor Horse Show in her waxed Barbour jacket, 1990. For the Queen's Diamond Jubilee in 2012, Dame Margaret Barbour offered the Queen a new jacket, but she declined, asking instead if her 25-year-old one could be rewaxed and spruced up.

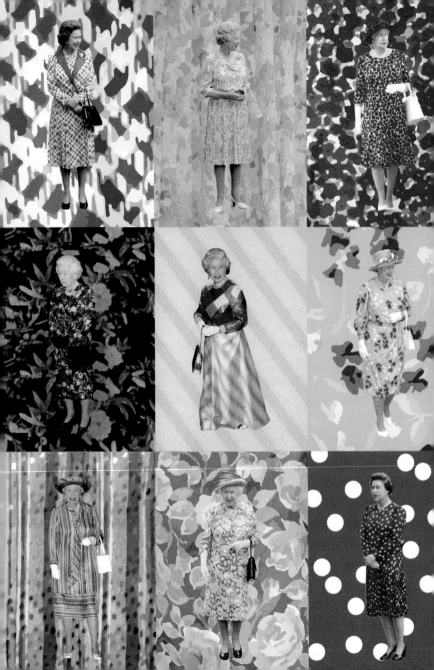

PRINT

When we imagine our Queen, we see
her in block colours – all pink, red, yellow
or green. But the monarch has a print
wardrobe of which Iris Apfel would be
proud. Spots, stripes, chevrons, tartans,
houndstooth, cheetah, sweet ditsy florals
and riotous, clashing blooms – the Queen
has worn them all and more. She may have
outgrown some prints – both leopard and
polka dot have been retired – but florals
and checks, it seems, are for life. There
have been some unexpected latecomers
too. Multicoloured harlequin diamonds
in her seventies? Why the hell not.

Admiring a display of flowers in a
conservatory at Balmoral Castle in 1972,
and clearly inspiring multiple Gucci
ready-to-wear collections and
advertising campaign shots, some
45 years later.

Visiting the Sandringham Flower Show in July 1987. The Queen loves flowers and is thought by many to wear Floris' White Rose, a blend of roses and carnations. The royal warrant-holding perfumery house also makes Royal Arms, a floral fragrance created in 1926, especially for the Queen's birth.

Clarence House, August 1988, to celebrate Queen Elizabeth, the Queen Mother's 88th birthday. Nothing more eighties than lurid butterfly prints and a stiff, lacquered hairstyle. (The Queen uses Kent combs and brushes on hers.)

Queen Elizabeth II meets children wearing national costumes during a visit to Tasmania, Australia, 1981.

July 2010. Queen Elizabeth II walks out of Government House to unveil a statue of herself, in Winnipeg, Canada. The Queen and Duke of Edinburgh were on an eight-day tour of Canada, starting in Halifax and finishing in Toronto, to celebrate the centenary of the Canadian Navy and to mark Canada Day on 1 July. The royal couple then made their way to New York where the Queen addressed the UN and visited Ground Zero.

Queen Elizabeth II smiles during her visit to New Zealand as part of her Silver Jubilee tour in March 1977.

With the Duke and Duchess of York outside Clarence House, August 1986. The Queen's preferred shoe heel height is 2.25 inches – not a fraction more.

'All my ideas are stolen anyway,' once said artist Damien Hirst. This Marie O'Regan dotty hat and matching placket was worn in Hungary in 1993, some three or four years after Hirst's own multicoloured dots came to the public's attention.

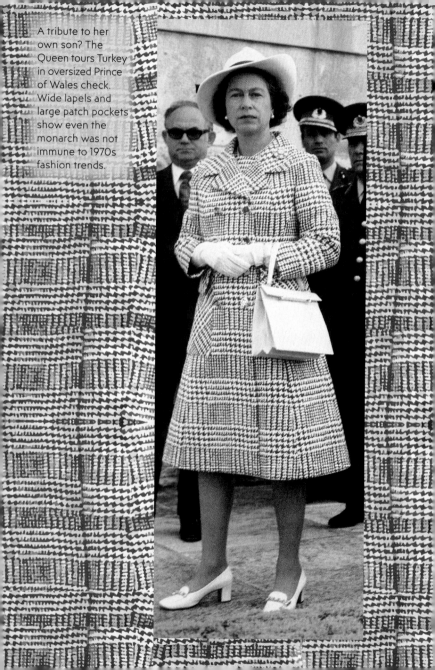

A tribute to her own son? The Queen tours Turkey in oversized Prince of Wales check. Wide lapels and large patch pockets show even the monarch was not immune to 1970s fashion trends.

With Prince Philip in Barbados during the Silver Jubilee year of 1977. Each of the Queen's looks is logged in writing by staff, to avoid any future repetition.

Harlequin diamond sequins and yellow stripes for the Royal Variety Performance at the Birmingham Hippodrome in November 1999.

The royal family's deep love of animals and nature, alongside their persistent, if waning, use of real fur in clothing, is confusing. In an ocelot scarf in 1958.

Leopard print could arguably be
classified as a neutral, but it represented
such a bold statement for the Queen
that its spiritual home is in prints.
In winter 1952, sadly before faux fur
become so good as to be undetectable.

During her Diamond Jubilee visit to the Isle of Wight, July 2012 – the Queen's last stop on her jubilee tour. While travelling, the Queen's ladies-in-waiting are said to always carry with them: travel sickness medicine, melatonin, an all-black outfit in case of tragedy, sealed lavatory tissue, a personal supply of blood, drinking water, pastries and Dundee cake, gin and red wine, a hot-water bottle.

On a walkabout in Barbados, November 1977. The Queen is rumoured to have a number of signals she communicates to nearby staff via the discreet positioning of her handbag during an engagement. These translate as follows.

Bag on table: We need to be wrapped up here in five minutes.

Swapping bag from one arm to another: Please interrupt my conversation and call me away.

Bag on the floor: Time to leave immediately.

On a 1993 visit to Cyprus, wearing a floral dress by John Anderson and hat by Philip Somerville. These pearl and diamond earrings and three-strand pearls have travelled everywhere with the Queen for several decades.

In Malta, November 1967, in a floral princess coat with three-quarter-length sleeves by Hardy Amies. The Queen favours this bracelet cut for its comparative neatness and decreased chances of trailing in food. Gloves (preferred length: 15 cm) bridge any gaps. She has paired the coat with one of her favourite brooches, the Cullinan V by Garrard.

In Fiji, 1977. The silk scarf is as closely associated with Elizabeth II as the Crown Jewels. At London Fashion Week, designer Richard Quinn showed a halter gown made entirely from silk scarves as part of a collection inspired by the Queen at leisure on the Balmoral estate.

Rare accord between the Queen and Princess Diana, as they celebrate the Queen Mother's 90th birthday in complementary bright florals at Clarence House, 1990.

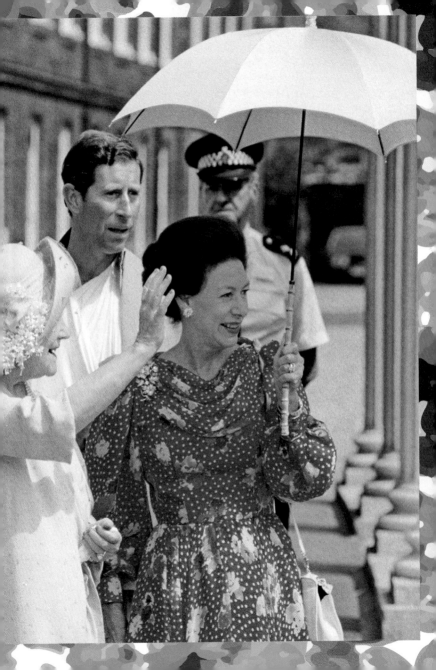

ACKNOWLEDGEMENTS

First and foremost, thank you to Georgia Garrett
at Rogers, Coleridge & White, the best agent anyone
could hope for. Huge thanks to Rowan Yapp for bringing
such a fun and unexpected project to me, and to
Sam Baker for letting me write *The Pool* column that
prompted her to get in touch. Thank you to Sophie Harris,
for making everything look so beautiful, to Louise Haines
for kindly agreeing to my involvement, and to Daniel Maier,
as always, for putting up with my schedule. I am most
grateful of all to the brilliant Lauren Oakey, who worked
so tirelessly and enthusiastically on the research
of this book. It simply would not exist without her.

CREDITS

© Alex Lane

SALI HUGHES is a journalist and broadcaster, specialising in beauty, women's issues and film. She has written for *Grazia*, the *Observer*, *Vogue*, *Elle* and *Stylist* among others and is resident columnist for *The Pool* and *Empire* magazine. She is also beauty editor for the *Guardian*. Sali is an experienced radio broadcaster and has made many television appearances. She hosts her own popular YouTube series 'In the Bathroom With...' and presents her own show on Soho Radio. In 2018, she co-founded Beauty Banks, a non-profit collective. Sali was written two bestselling books, *Pretty Honest* and *Pretty Iconic*. She lives in Brighton, England, with her two sons and husband.

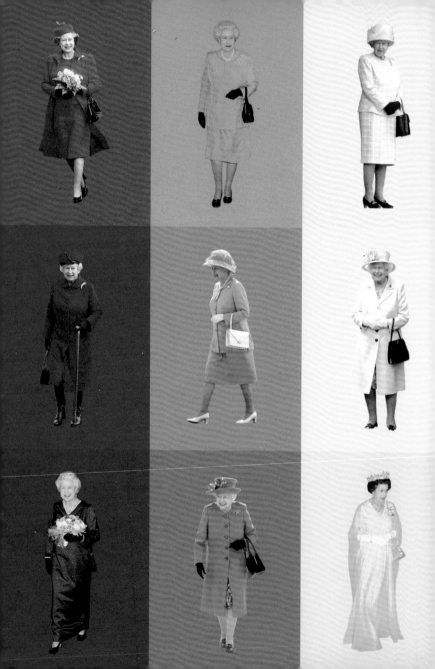